Creative Digital Photography

O9-BUC-035

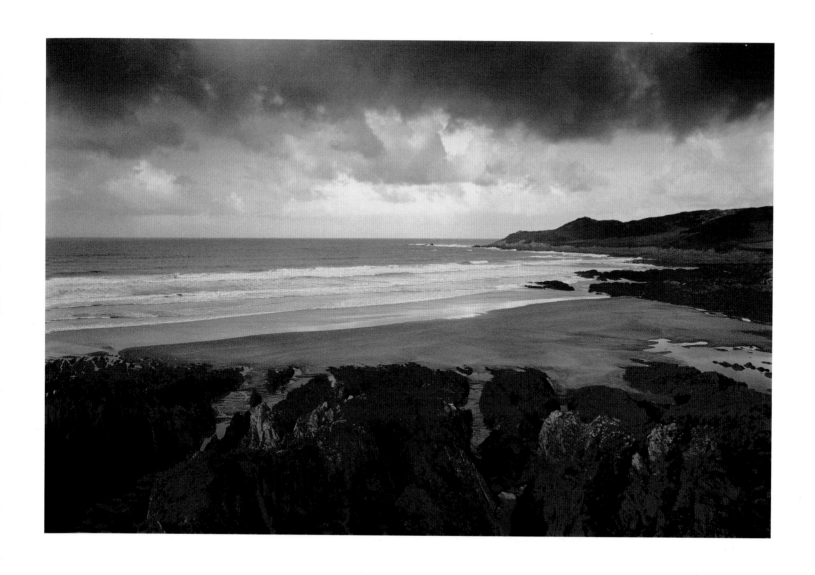

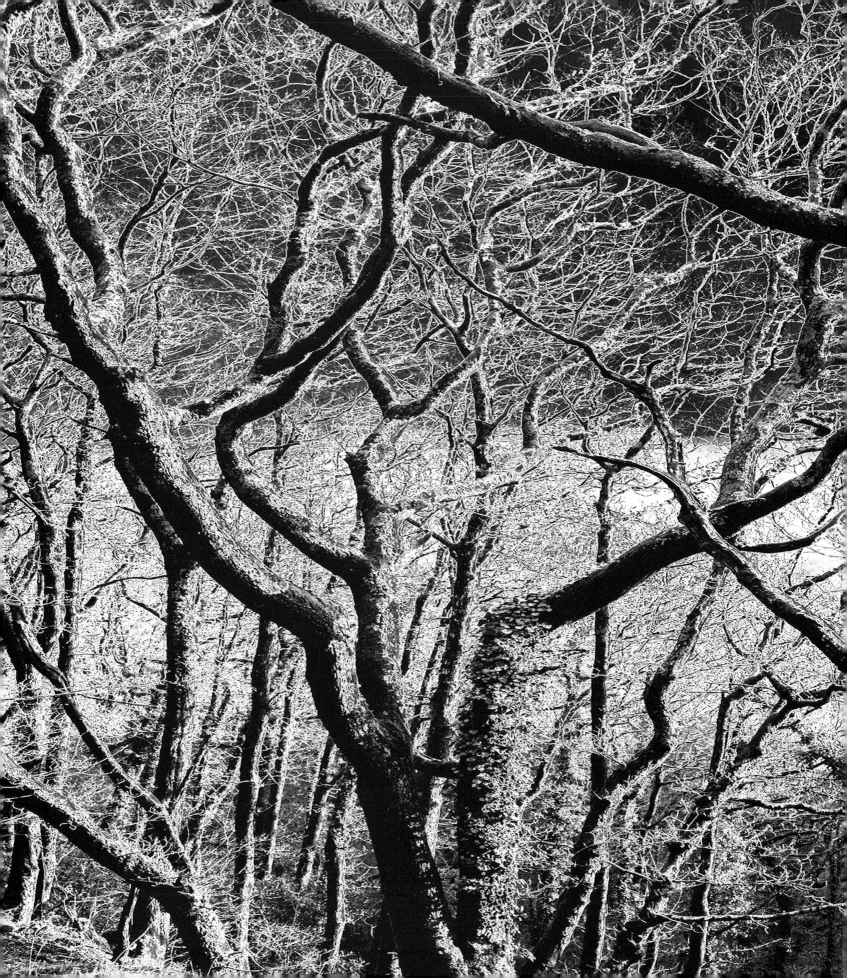

Creative Digital Photography

Michael Busselle

Amphoto Books
An imprint of
Watson-Guptill Publications/New York

LIBRARY
FRANKLIN PIERCE COLLEGE
RINDGE NH 03461

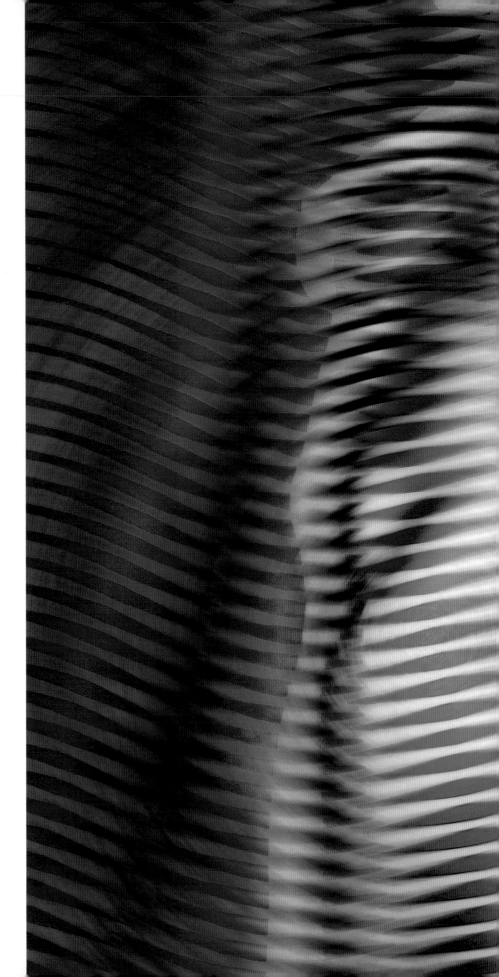

First published in the United States in 2001 by Amphoto
Books, an imprint of Watson-Guptill Publications, a division of
VNU Business Media, Inc.,770 Broadway, New York, NY 10003
www.watsonguptill.com

First published in the UK in 2002 by David and Charles

Copyright © Michael Busselle 2002

Michael Busselle has asserted his right to be identified as
author of this work in accordance with the Copyright,
Designs and Patents Act, 1988.

All rights reserved. No part of this publication may be
reproduced or used in any form or by any means—graphic,
electronic, or mechanical, including photocopying, record-
ing, or information storage-and-retrieval systems—without
the written permission of the publisher.

Library of Congress Catalog Control Number available from
the Library of Congress
ISBN 0-8174-3730-4

Printed in China

Publishing Manager Miranda Spicer
Commissioning Editor Sarah Hoggett
Art Editor Diana Dummett
Senior Desk Editor Freya Dangerfield
Production Controller Roger Lane

1 2 3 4 5 6 7 / 08 07 06 05 04 03 02

(PAGE 1) **Mortehoe seascape**
*From a 35mm negative shot on Ilford XP2 with a
35mm camera, I converted the original to RGB and
used the Select/Colour Range and Colour Balance
controls to produce this lith-style monochrome image.*
(PAGES 2–3) **Winter trees**
*The original was a medium-format black-and-
white negative exposed on Ilford XP2. I created the
effect shown here by combining two layers with
different levels of contrast, and adjusting the blend
in Layer Options.*
(RIGHT) **Nude moiré**
*I layered a nude image with a close-up of a moiré
pattern and used Curves and Blend modes, and radial
blur to create this effect.*

Contents

Introduction

My first book on photography was published 25 years ago and since then there have been a good few more. I've witnessed and recorded the changes in style, advances in technology and the wider perception of the medium during this period, and many of them have been sweeping.

But as far as the practice of photography is concerned there has been very little along the way that was radically different. Cameras have become easier to use, the design of lenses has advanced considerably, metering systems have become more accurate and auto-focusing is now almost standard. The reproduction quality of film and paper has also been raised appreciably during this time, and processing methods vastly simplified; but the basic instruction and advice that someone like me could offer to newcomers to the medium changed little in essence – until now.

This book is different. For the first time in 25 years I am able to describe and illustrate techniques and effects that are completely new and that had previously not been possible.

After nearly 50 years as a practicing photographer I had reached a point where I was beginning to feel that I was in danger of repeating myself with many of the potential subjects I saw, and I often found myself not taking a good picture simply because I'd already shot something very similar a good many times before, or had seen it done rather too often by others. I had also become more finicky over my images, and had begun to be disappointed with some photographs simply because a particular color in an image was not quite the hue I would have liked, or the contrast was a little too high or low, or there was a small distracting detail in the background of a shot. It reached a point where I was holding back from taking an otherwise potentially strong shot for these relatively trivial reasons.

But once I started to experiment with digital image control I realized that I could approach my photography in a new way, and I began to see even familiar subjects differently. Because I'm now regarding the images I've recorded as being something that can evolve, rather than simply as an end product, it has resulted in a greatly renewed enthusiasm and fresh inspiration for my photography.

Initially I began to work with photographs I'd already taken, sometimes many years ago. But now I'm shooting images on film that I know will produce unusable transparencies because I know can develop the image into something much more interesting.

The photograph of Venice shown opposite is

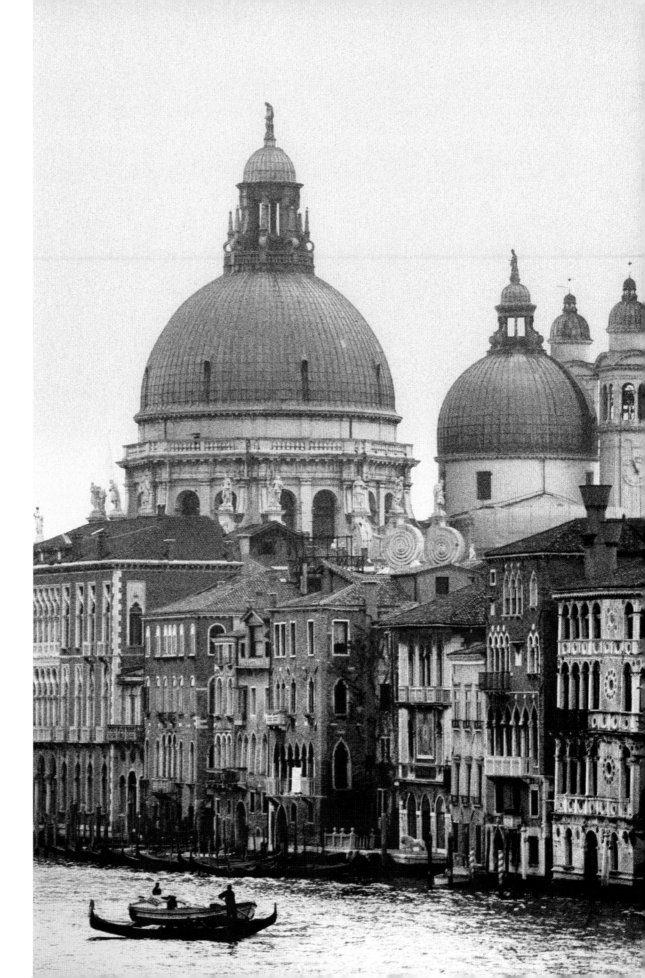

Venice

I shot this scene using a long-focus lens on a 35mm camera loaded with Fuji Velvia. The effect was created by increasing the colour saturation and contrast of the original transparency, together with a small amount of added Noise.

an example. A misty, wet day created such a soft light that I knew the Velvia transparency would be flat and colorless, but I could visualize how I might produce a pleasing image from it. I had two ideas. One was a lith-style monochrome, which also worked very well; this was the other. The image you see reproduced here is essentially the same image as recorded on film but with an increase in color saturation and contrast together with a change of color in the sky.

The Spanish landscape on this page is not radically different from the original transparency, shot on Velvia, but I improved the sky, removed some intrusive power lines and added the sun.

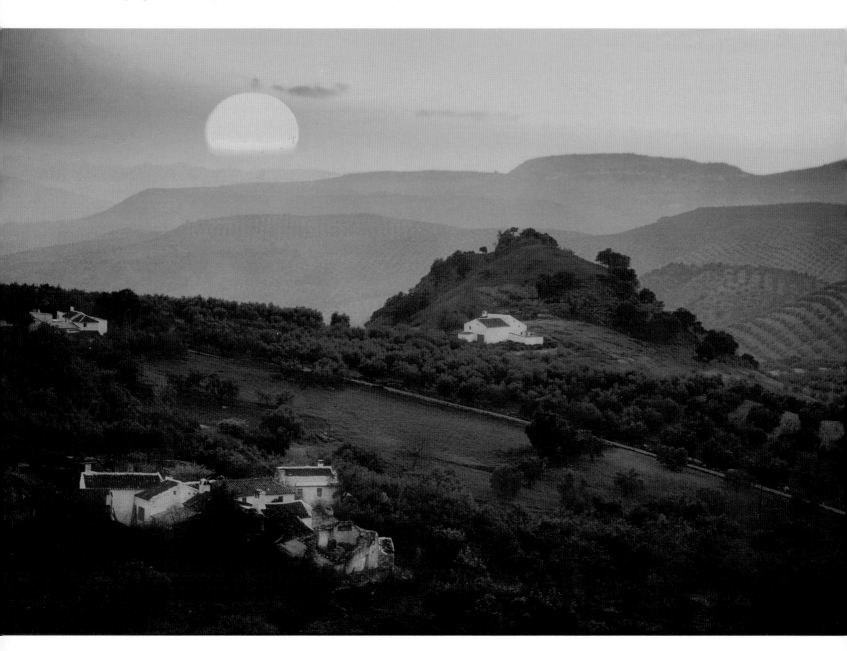

The seascape on page 1 was shot on Ilford XP2 with the intention of producing a lith-style monochrome. You may ask, why not make a lith print? The truth is that, although I love black-and-white photography, I really do not like spending long hours in the darkroom with my hands submerged in noxious fluids. And I'm not keen on some of the colors that the lith process often produces and am frustrated by the lack of control.

Part of the appeal of black-and-white photography is that the control over image and print quality that can be applied in the darkroom allows a photographer to feel that he or she is doing much more than making a straightforward record of a subject and is producing a image that has a very personal stamp. But this has not previously been possible, to any great extent, in color photography, until now. Of course, having a good eye and being in the right place at the right time, remains the key to good photography, but with a digital image I do feel now that I am much more in control of the final outcome.

The ability to control an image digitally is, I believe, the single most exciting and liberating development in the medium since the introduction of roll film and the 35mm camera. It's also exciting to know that now I can show someone on the other side of the world some of my photographs, almost instantly, at the click of a mouse.

I do, however, feel that software such as Photoshop should be issued with a warning similar to those on cigarette packets. I have in mind something like "Using this product can seriously undermine your artistic judgment." It has to be said that the sheer power of image-editing programs can easily go to your head, and for every image that has been genuinely enhanced, or imaginatively created, there are many thousands that should never see the light of day. Trying to rescue dire pictures by digital means is a road best not traveled and you should heed the computer operator's maxim, "If you put garbage in, you get garbage out."

I doubt that the thrill of seeing that very first coil of film lifted glistening and wet from the processing tank, or the feeling that I've just pressed the button on a stunning image will ever be surpassed, but for me, the possibilities offered by digital image control come very close. Taking photographs remains my great passion but I can now do so with the knowledge that the process has not necessarily ended at the moment I press the button.

Michael Busselle

Spanish landscape
The original was photographed on a 35mm camera with a long-focus lens and Fuji Velvia film. I removed some intrusions, enhanced the quality of the sky, and added the sun.

Organizing the Image

The camera sees in a completely different way from the way we do, so to take good photographs consistently it's necessary to train your eyes to see in the same way.

It's significant that a camera lens is sometimes known as an "objective" as it sees in a very cold, dispassionate way. But we, on the other hand, see in a very subjective way, focusing on things that interest us and ignoring those that don't.

Having a "good eye" is a something to which all photo-graphers aspire. Some, like Henri-Cartier Bresson, seem to have been born with it, but it can be acquired with a little practice. It's simply a matter of learning to see like a camera. There are a number of tangible visual qualities that the camera will record in a way that can have a powerful effect in an image and create considerable impact; the following chapter describes them.

Tuscan trees
A good choice of viewpoint and careful framing produced this nicely balanced composition.

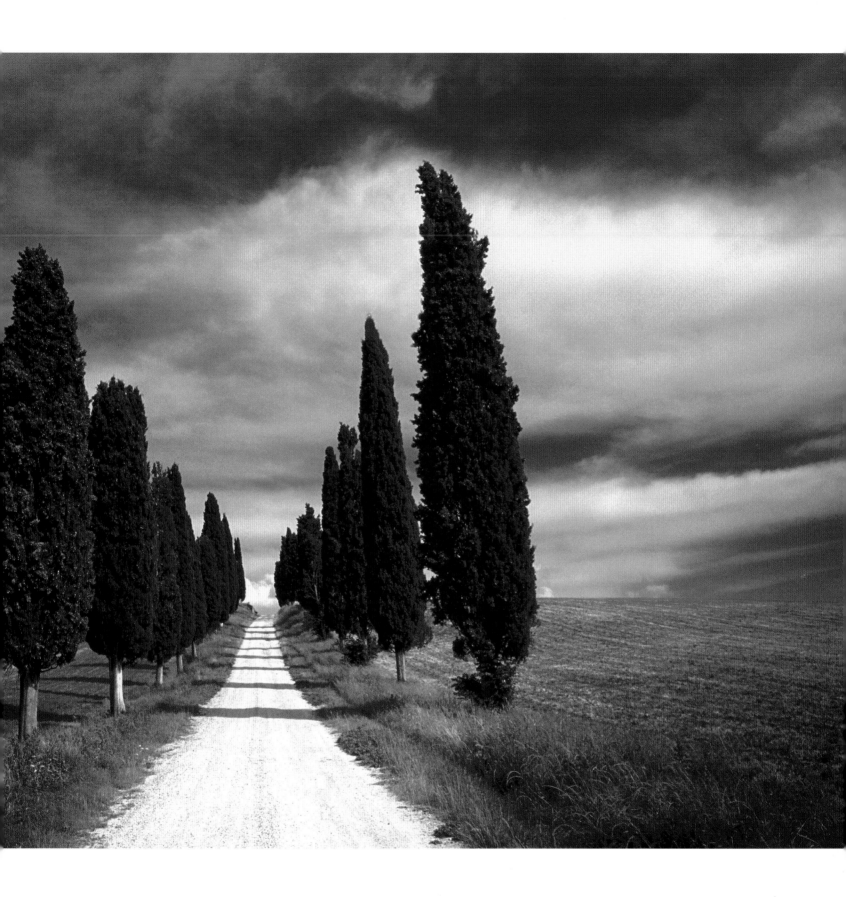

Seeing Beyond the Subject

The most important step in acquiring a photographer's eye is to look beyond the subject itself and to identify the crucial visual qualities that can be so striking in a photograph. Some of these can be inherent in the scene, such as color, texture and shape, while others can be revealed or enhanced by lighting.

These key elements are effectively the building blocks of a photograph, and even if just one of these elements is particularly striking in some way it can create an interesting image. When two or more of these components have a strong presence in a subject, you are likely to produce a powerful image.

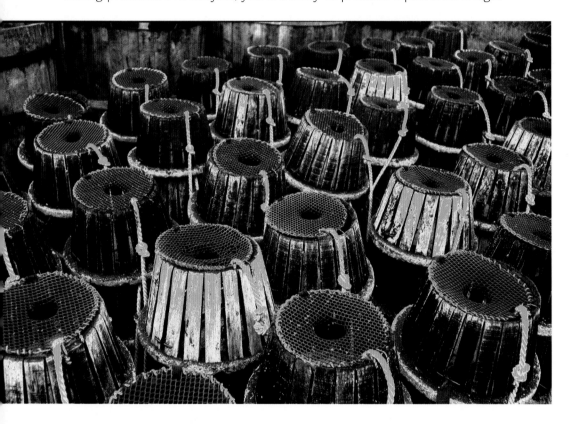

Shapes creating patterns
I was attracted by the pattern effect created by this pile of lobster pots on a beach in France. I used a high viewpoint in combination with a wide-angle lens in order to look down on them and, at the same time, included as many of them as possible in the camera's frame.

shape

The dominant shape of a subject often can be the most striking element of an image. It might be the shape of a principal object, such as a tree silhouetted on a skyline, or a cloud in the sky. It can also be when a shape is created by an arrangement of objects, in a still life, for example, or a shape created by perspective. This element is much stronger and has more impact when the object in question is clearly defined and stands out from the background; this happens when there is a bold tonal or color contrast between them, or when the object's outline is emphasized by lighting.

pattern

The effect of a pattern is created when a number of similar shapes are placed together in an image, and it can have a quite compelling effect, even when the pattern is only suggested. But pattern alone tends to have only an initial impact, and other elements, such as a break in the pattern to create a focus of interest, are usually necessary to give a picture a more lasting interest.

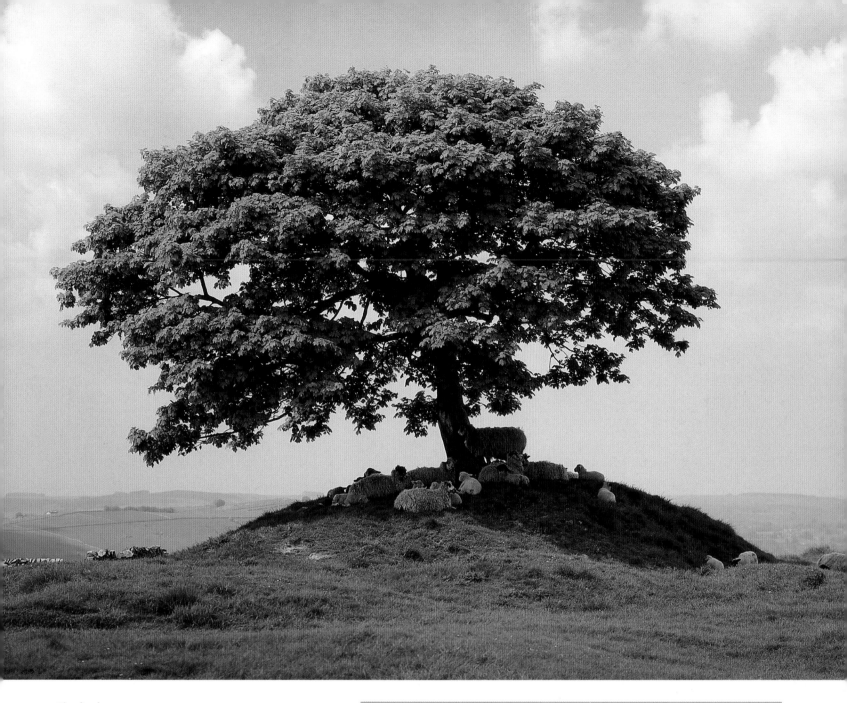

Single shape

It was the very pleasing shape of this tree in England's Peak District that struck me, and the fact that it was raised up on a small hillock, with the silhouetted sheep below it. I used a low viewpoint in order to place the tree against the sky.

TECHNICAL NOTE

Inexperienced photographers often fall into the trap of composing their pictures by eye and using the camera's viewfinder simply as a means of aiming the camera. Doing this tends to make you concentrate so much on the main subject in the center of the frame that you become much less aware of other elements within it. Always study the edges of the frame first when viewing a subject, as by doing so, you can ensure that nothing is included that should not be there.

form

Although the shape of an object can have a powerful effect, and even a complete silhouette can have considerable impact, a more interesting and satisfying image usually results when the objects within a scene have a feeling of solidity. The photographic medium is capable of creating an almost uncanny sense of depth, and can give the impression of being three-dimensional on the flat surface of a print or transparency. This quality is created by the tonal range of the subject, which is often at least partly dependent upon the way it is lit. As a general rule, a fairly gentle gradation from the darkest shadow to the brightest highlight within an object tends to create the strongest impression of form and solidity.

texture

The way in which a photograph can recreate the texture of an object's surface can be so convincing that it often invites a tactile response from the viewer. In furniture manufacture, for example, photographic reproduction is often used to simulate surfaces like wood grain and fabric on materials such as laminate. Like form, the impression of texture is dependent upon the tonal range of the subject and in the way it is lit, and it is an invaluable aspect of a photograph's ability to produce images with a powerful sense of realism.

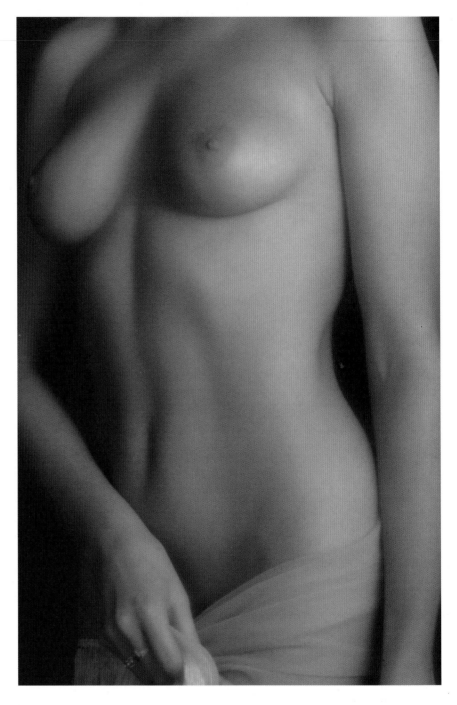

Lighting for form
I photographed this nude in the studio using a single flash that was heavily diffused by a translucent screen positioned quite close to the model at an angle of 45 degrees to her body. I used a white reflector close to her on the opposite side, to prevent the shadows becoming too dark and to ensure that the transition from highlight to shadow was quite gradual.

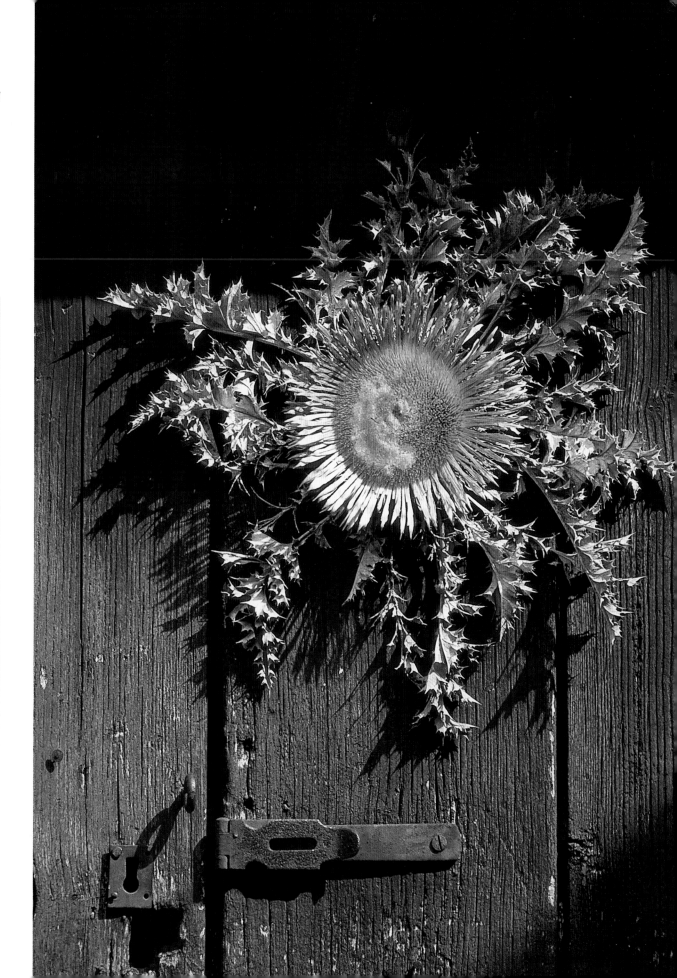

Using angled light
Bright sunlight directed at an acute angle across this cottage doorway created a strong impression of texture on the dried sunflower and the weathered wood.

TECHNICAL NOTE

It is essential for the image to be bitingly sharp if the texture of a subject is to be fully exploited and the finest details in the image are to be recorded. It is for this reason that photographers often choose to use large-format cameras, but excellent results can be obtained with 35mm and medium-format cameras – use a small aperture to obtain good depth of field, and use a slow, fine-grained film (or a high resolution setting on a digital camera) to reveal the greatest detail in the image.

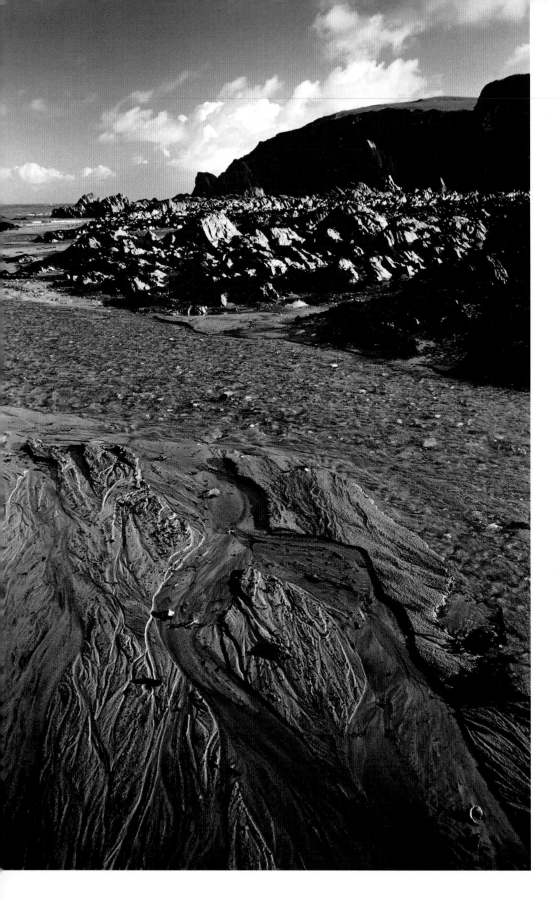

perspective

While visual elements such as texture, tone and color help to establish the character of an image, perspective, like shape, is largely responsible for creating the image's basic structure. The effect of perspective is produced when the size of similar objects appears to become smaller the further they are from the camera, such as when looking along a row of houses or down an avenue of trees. The effect is exaggerated when a wide-angle lens is used and objects both very close to and distant from the camera are included in the frame.

color

Millions upon millions of color photographs are taken every day, every other shop or store sells rolls of color film, and one-hour photo labs can be found on almost every corner – and yet very few really good color photographs are actually produced from all this. There is a popular belief that all you need to take a color photograph is to load up with color film, but the stunning photographs

Wide-angle perspective
I used a wide-angle lens and placed the camera quite close to the ground in this beach photograph in order to make the sand pattern dominate the image, while also helping to create a strong impression of depth and distance. I used a small aperture to ensure that both close and distant details were sharp.

you see in books and magazines are invariably the result of a great deal of thought, time and effort being given to the color content of the image.

Many people who are very observant and discerning over color when choosing clothes or decorating a room simply don't seem to notice color at all when taking a photograph, but the key to good color photography is to be fully aware of each and every color within a scene, and to see how successfully – or otherwise – they work together.

Most people are likely to be inspired to take a picture when confronted by a particularly colorful scene. Paradoxically, this is often a situation in which it is most difficult to produce a striking color photograph. A subject that contains a mixture of bright colors will almost certainly produce a dis-appointing image unless a very selective and restrained approach is adopted.

TECHNICAL NOTE

Pictures with a mix of bright colors can often be made to work when they have a bold design or shape that dominates the image. But very often the most striking color photographs have just a single, dominant color that is the main focus of attention, with the other colors and details of the scene creating a pleasing and harmonious balance around it.

Contrasting colors
The bright red clothes of this little girl on a Spanish beach contrast strongly with the bluish sea in the background and create a quite striking effect.

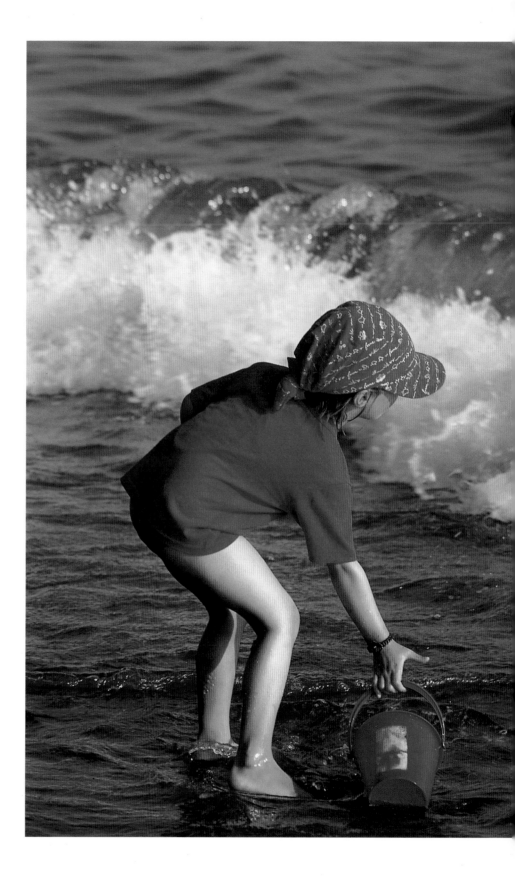

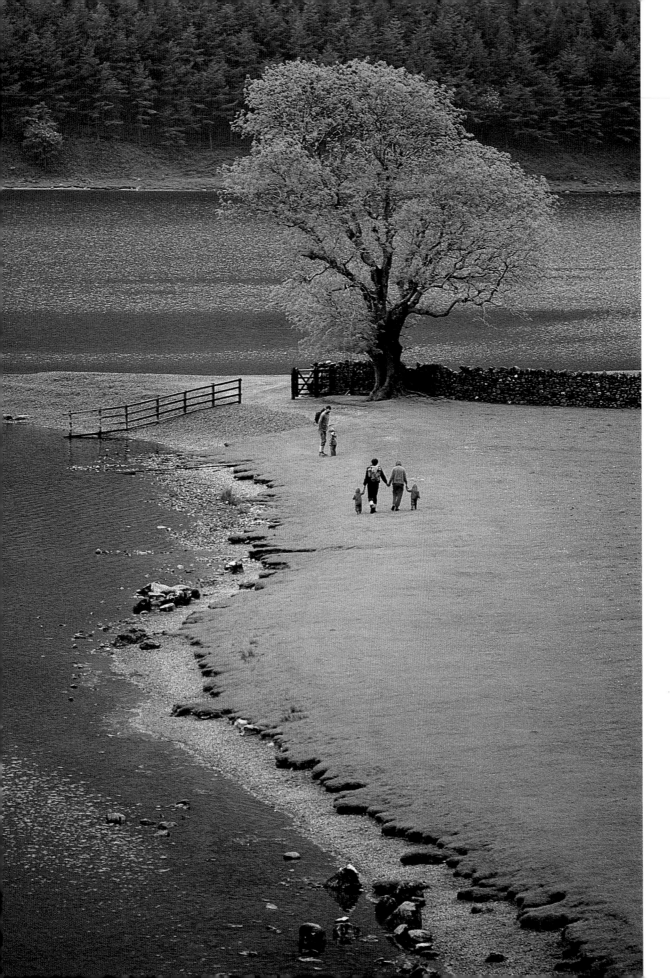

Placing the dominant image

I photographed this corner of Buttermere in the English Lake District on a spring day when the sunlight was diffused by haze. The soft color quality helped the group of walkers become the most dominant feature of the image, and I emphasized this further by framing the image so that they were placed near the strongest position within the frame, on the intersection of thirds.

TECHNICAL NOTE

The majority of photographs are taken from the photographer's eye level when standing. But even just a slight change in the camera level can often make a significant difference to the composition of an image, such as shooting from a kneeling position, for example, or standing on a stool. These effects are much more noticeable when a wide-angle lens is used.

Composition and Design

While studio photographers are able to exercise some control over the content of their images, those shooting subjects such as landscape, architecture and nature are largely in the position of having to achieve a well-composed picture solely by their choice of viewpoint and the way in which the subject is framed.

But the advent of digital photography has gone a long way to providing photographers with a freedom of expression similar to that enjoyed by painters, with the ability to combine images and individual elements on a computer screen in an almost limitless way. When using this medium, the photographer also needs to become a designer in the true sense of the word.

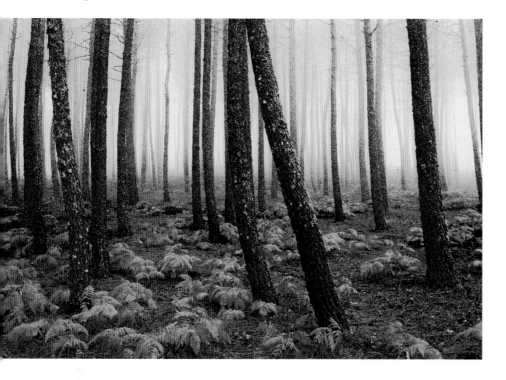

Finding the viewpoint
My choice of viewpoint for this image, of a forest in the Spanish Sierra de Gredos mountains, was dictated by looking for the most pleasing arrangement of the tree trunks. The mist made them much more prominent than they would have been on a clear day, and I wanted to find a way of juxtaposing them to produce an ordered and balanced image.

viewpoint

The choice of viewpoint is perhaps the single most important decision to be made when considering how the image should be composed in the camera, as it establishes the relationship between the subject and the other elements in a scene. When the camera is moved closer to the subject it becomes larger in relation to distant details and more dominant in the image, while moving the camera further from the subject makes background details larger in proportion to the subject and the foreground less dominant. Moving the camera to the right makes a subject in the foreground appear to move to the left of distant objects, while moving the camera to the left has the opposite effect.

framing the image

Having decided on the best viewpoint, the next step is to consider how the image should be framed. In order to do this it is first necessary to establish a focus of interest within the scene – this might be something very obvious, such as a prominent building in an otherwise uninhabited landscape, or something quite subtle, like a splash of color or a highlight that stands out from the rest of the scene. Once identified, this detail can act as a fulcrum around which the other elements of the subject can be balanced, by deciding where the focus of interest can be most effectively placed within the frame, and which of the remaining details should be included or excluded.

TECHNICAL NOTE

In most cases there is no best viewpoint or one perfect frame, and it can be very instructive to try several alternatives. Quite often I find that the version that seemed best at the time of shooting the picture is less effective than one of the alternatives. This is a good way to develop a personal style and to avoid your images becoming too predictable.

Moving the elements
This picture was composed on the computer screen using separate images of the sky, beach and seagull. By juggling the position of the horizon and gull images, I was able to produce an image with a good overall balance, but which still retained a sense of movement and tension.

balance and tension

The place within the frame where the main focus of interest has the greatest effect is said to be at the point where lines that divide the picture area into thirds intersect. There is no doubt that in many cases this produces a well-balanced and pleasing effect, and it can usually be considered a safe option. However, there is rather more to it than this, and your aim should always be to strive for a sense of balance in the image – and this is dependent upon the size, shape and color of the main elements of a scene.

For example, a landscape photograph that is divided equally by the horizon is generally best avoided, as the result can easily be too symmetrical and static. But if the dominant features in a scene lie both above and below the horizon line, it can be much more important to frame the image in such a way that a good balance is created between them, even if this results in a centrally placed horizon.

In addition, think in terms of creating a sense of movement and tension within your images. Some contemporary photographers use devices such as deliberately tilted horizons, distracting details at the edge of the frame, and pictures cropped in unexpected ways. While this approach can lead to rather contrived and self-conscious images, it can also help to open your mind to other ways of seeing a subject and of avoiding clichés.

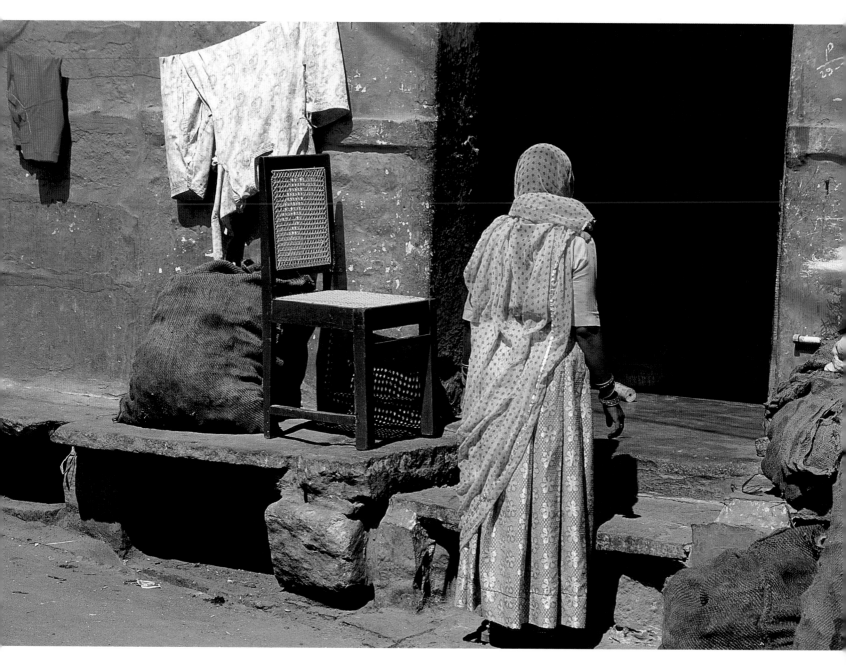

Creating tension

I framed this picture, taken in Jaisalmer, India, so that the small piece of red fabric was included near the left-hand edge of the frame. This introduced an element of tension into what was otherwise a neatly framed and potentially rather static image.

Light and the Image

While the choice of viewpoint and the composition of an image are vital to the effectiveness of a photograph, it is often the way in which a subject is lit that is the ultimate factor in creating a really striking image. The relationship between the subject, the light and the final image is perhaps the single most fascinating aspect of the medium – and the most elusive

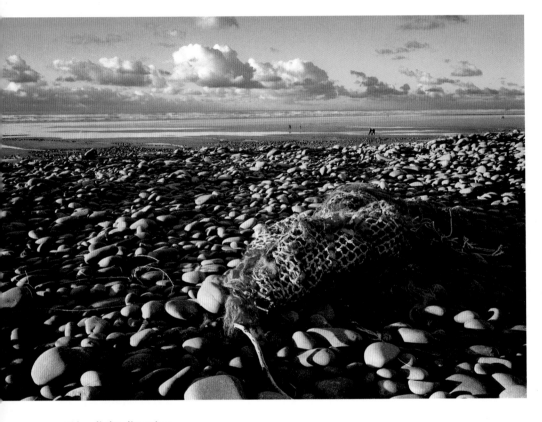

Using light direction
I photographed this scene, at Northam in Devon, England, late on a winter afternoon. The low angle of the sunlight produced bold shadows, making the stones in the foreground a dominant feature of the image. The warmish tint of the sunlight also helped to give the image a rich color quality.

light intensity

There are three essential ways in which light affects a photographic image: intensity, direction and quality. Intensity is important because it determines the amount of exposure needed to record an image on film or other image receptor. With a completely static subject and a tripod-mounted camera, long exposures can usually be given to compensate for a poorly illuminated subject, but with a moving subject or a hand-held camera, a short exposure is necessary to prevent blur. In these circumstances, a fast film or more sensitive receptor is needed when the light level is low.

light direction

The angle from which light is directed towards a subject is a vital factor in determining how effectively the key elements within it, such as form and texture, are recorded. In landscape photography, for instance, a scene that can appear stunning in early morning sunlight may seem bland and uninteresting later in the day. But the direction of light in relation to the subject is also governed by the camera's viewpoint, and the effect of light is often another factor that should be considered when choosing a viewpoint.

TECHNICAL NOTE

The shadows in a scene are the best guide to judging the way in which the direction of the light affects the subject and the way in which it will be recorded. In many ways they are responsible for creating the basic structure of an image, and once you are aware of their size, direction and density, you can begin to see more clearly how effectively the image will be recorded, and if any changes need to be made in the choice of viewpoint and the way in which the image is framed.

Low light level

It was a cloudy, overcast day when I photographed this deserted barn in France, and the very soft light produced only very weak shadows. The dense, hard-edged shadows created by direct sunlight would have resulted in too much contrast and detracted from the subtle colors and textures of the stone and foliage.

Orange cast

This photograph of Bryce Canyon in Utah was taken just after sunrise, when the orange-tinted color of the sunlight enhanced the color of the rocks. The low angle of light created strong, sharp-edged shadows, producing an image with rich color and bold contrast.

TECHNICAL NOTE

It is very easy to misjudge the contrast of a scene when viewing it in the normal way, because our eyes are very accommodating and can see clearly into dense shadows. Looking at a subject through half-closed eyes, or through the viewfinder of an SLR camera with the lens stopped down, is an excellent way of judging the contrast of a scene more objectively. So, too, when viewing a digitized image on a camera or monitor screen, as this also can show more detail in shadow and highlight areas than can be recorded on a print or in reproduction processes.

Here, the soft, blue-tinted light of open shade on a sunny day resulted in an almost shadowless image with lots of detail, and the bluish quality of the light accentuated the color of the flowers.

light quality

The quality of light refers both to the degree to which it is diffused, and to its color. The effect of light at midday from an overcast sky, for example, is completely different from that when clear evening sunlight illuminates the same scene. The degree of light diffusion affects the contrast of a scene: the strongly diffused light from an overcast sky produces weak shadows and no bright highlights, and can make a subject record as a flat and lifeless image, whereas the dense shadows and bright highlights created by strong, direct sunlight produce very high contrast and can record images with a harsh quality that lacks detail.

The color of daylight can vary enormously, from the strong orange tint of early-morning and late-evening sunlight to the pronounced blue cast of light on overcast days and when light is reflected from a blue sky onto subjects in open shade. Color film is designed to produce optimum results under quite limited contrast levels and with a specific color of light, and there can be a significant change in image quality when these factors are outside the tolerance of the film.

The warm, orange-tinted color of sunlight when it is low in the sky can contribute to the mood and effect of some subjects, such as landscapes and architecture, but a blue cast is usually less desirable. When working with digitized images, both the contrast and color balance of an image can be adjusted relatively easily.

Enhancing the Image

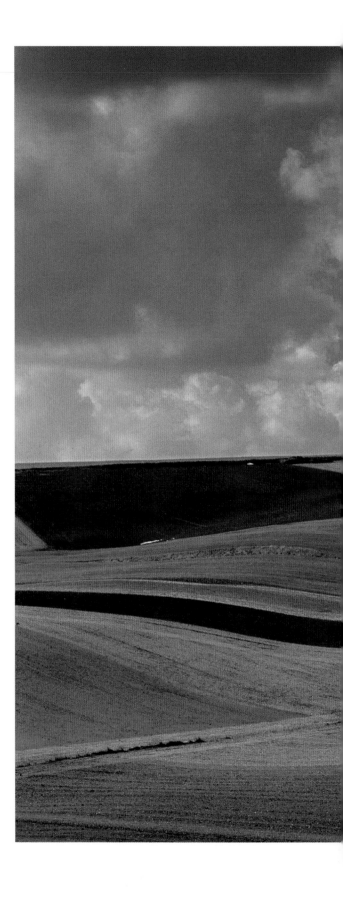

When the photographic medium was first discovered more than 150 years ago, the process of recording an image on a light-sensitive surface was considered to be little short of miraculous. Those early pioneers of photography would be astonished to see just how far the medium has progressed with both cameras and film. But, in truth, even with the latest developments in silver halide photography, fine control of image quality can be a frustratingly restricting process.

However, a digital image that is formed from pixels instead of silver halide grains allows a vast new range of controls to become possible, from simple adjustments of density, contrast and color, to the removal of blemishes, the conversion of an image from color to monochrome, and the introduction of a wide range of effects. This chapter describes the first steps in discovering the possibilities of this exciting new photographic process.

French fields
Basic adjustments to the colour quality and tonal range of this photograph have improved it greatly without altering its essential nature.

 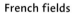

Cropping the Image

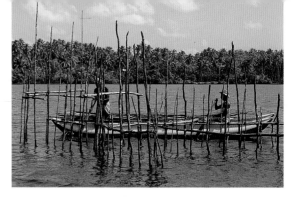

While some photographers insist that their photographs are not cropped in any way, there are very few negatives that would not benefit from a little judicial cropping. I make every effort to exclude details I do not want in my pictures at the time of shooting, but there are occasions when the shape of the film format or the choice of lens means that some unwanted details appear.

The Cropping tool can therefore provide a good opportunity to see whether your picture may have more impact if a little less is included in the frame. This can often be the case when using compact cameras, for example, as the viewfinders of this type of camera have a built-in safety margin, which results in more of the scene being included on the film, or the memory card, than was visible at the time of shooting. When working with digital images, there is also a very good case for cropping out elements that are not wanted, as doing so can reduce the size of a file quite significantly, thus taking up less space on your hard disk.

cropping the sky

I took this picture in Sri Lanka using a 35mm camera, and framed the subject tightly enough to exclude unwanted details on each side of the boat. After scanning, I viewed the image on the screen and became aware that the relatively large area of sky rather detracted from the main subject of the picture. My first thought was to make the sky darker and thereby less obtrusive, but I then realized that if I cropped the sky out altogether I would be left with a panoramic format. When I tried this, the effect of the boat, the background trees, the upright wooden stakes and their more saturated colors made a much more striking image.

(BELOW) **Sri Lanka boat**
Using the Cropping tool enabled me to remove the bland and uninteresting sky and create a panoramic image.

(ABOVE RIGHT) **Original image**
For this, I used a 35mm camera with a mid-range zoom lens and Kodak Ektachrome 64 film.

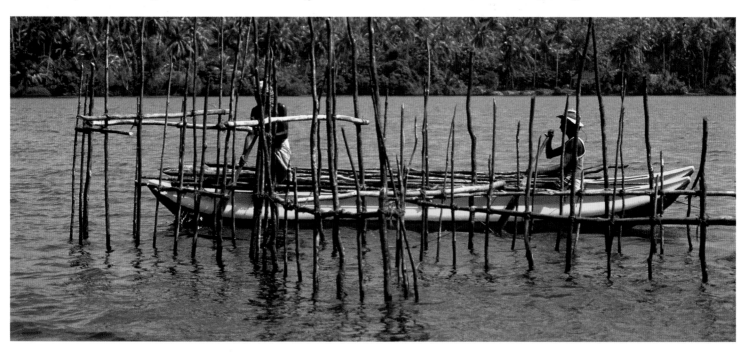

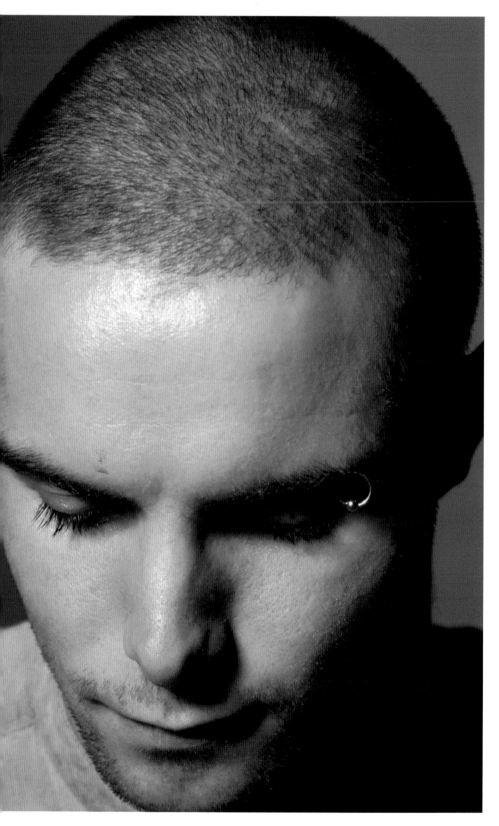

cropping to the essentials

I photographed this man in my studio using a highish viewpoint, and positioned his head with the aim of accentuating the textural quality of his close-cropped scalp. I also framed the picture quite tightly in order to give it further emphasis. But on viewing the image on-screen after scanning, I felt that the way I had framed the image was still a bit too loose, leaving it with less impact than I would have wished. Using the Cropping tool, I removed much more of the picture area and included only the essentials of the head and face; this made the image stronger and gave it a more dramatic quality.

(LEFT) **Punk**
I felt the image would have more impact if it were more tightly framed, so I used the Cropping tool to remove all but the essential details.

(BELOW) **Original image**
The portrait was photographed using a medium-format camera, a long-focus lens and Fuji Astia film; it was lit using studio flash.

Adding a Border

Even the best photographs can be enhanced by good presentation, and black-and-white workers often pay great attention to the borders of a print. Using an oversize negative carrier in the enlarger, which enables the film rebate to be used as a print border, is one way of achieving this and avoiding the standard white border produced by the masking frame. Some fine-art photographers file the edges of their negative carriers to create a ragged, arty effect; and the effect of a vignette, created by holding the image back while printing, can enhance the quality of a portrait.

The opportunities to add borders and ragged edges are boundless when using an image-editing program such as Photoshop, and there are also special programs available that can introduce an enormous variety of effects.

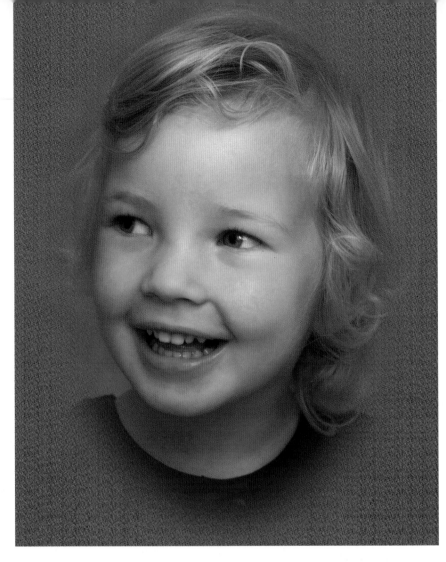

TECHNICAL NOTE

A more individual and creative effect can be achieved by drawing or painting your own edges and then scanning them in order to add them to your images. You can also create edges and borders from photographs of natural textures, such as wood grain and fabric.

adding a background

I photographed this young girl in the studio, selecting a painted blue background to enhance her blond hair and delicate skin tones. I thought the image could be made to appear softer and more appealing if I vignetted the image. I used the Elliptical Marquee tool to draw a suitable shape close around the girl's head and then inverted the selection and added a feather of about 150 pixels. I then selected a background color by sampling the blue paper, and filled the selected area with it. A finishing touch was to add a subtle texture to this area using Filter/Texturizer/Texture-Canvas.

Young girl
I used heavily diffused studio flash to light this portrait, and photographed it on a medium-format camera with a long-focus lens and Fuji Astia film. To soften the image I added the effect of a vignette to create a frame around it.

creating a frame

Having been attracted by the almost unreal colors of the goods on sale, I shot this garish image (below) at a small seaside shop on the Costa del Sol in Spain. It occurred to me that it might be fun to add a similarly over-the-top frame around the image. I selected the background color by sampling the strongest blue in the image, and then, using Image/Canvas Size, I increased it by about 12mm all round. I then repeated the process, this time sampling the brightest yellow for a smaller area of additional canvas; and lastly selected the most saturated red in the image for the final, slightly larger increase in canvas size.

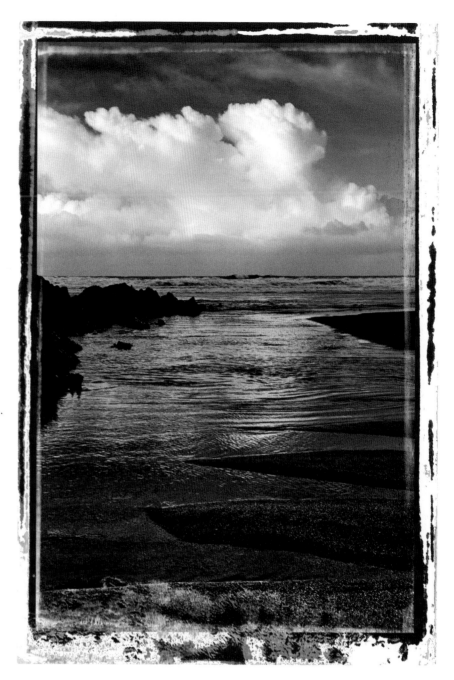

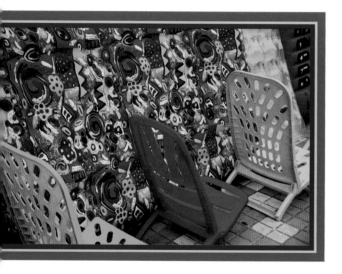

Beach chairs

I used Fuji Reala color negative film with a 35mm camera and a mid-range zoom lens for the original arrangement. Extending the canvas area in three stages created the effect of a multicolored frame.

Seascape

The colors were created from a black-and-white negative by converting to RGB and using the Color Balance and Layers controls. The frame was added using Extensis PhotoFrame.

Blemishes and Intrusions

The fragility of photographic film makes it essential that it is handled with great care. However, as all photographers know, no matter how much care is taken, dust or abrasions show up on prints with annoying regularity, and this can sometimes result in hours of careful spotting to rectify the problem. One of the great advantages of a digitized image is that this fault can be much more easily dealt with, and even photographs that have been quite badly damaged can be made as good as new with a little care, and in a way that is undetectable, by means of the Rubber Stamp or Cloning tools. The same technique can be easily extended to remove details within the subject that are unwanted and intrusive, such as a vapor trail in the sky of a landscape shot.

Original image
I shot this on a 35mm camera fitted with a mid-range zoom lens and Fuji Reala color negative film.

removing dust marks

I photographed this scene early one morning on the Costa del Sol as these two ladies took their daily exercise. This type of image is bound to reveal dust marks as there are large areas of plain mid-tones, and although I cleaned the color negative carefully before scanning, the image was peppered with minute white spots. These were easily taken care of using the Rubber Stamp, but there were other intrusions that I wanted to remove. On this part of the coast the sand is volcanic and appears almost black in this light, with the result that pebbles and litter showed up very strongly against it. This detracted quite significantly from the image, so I extended my spotting activities to this area.

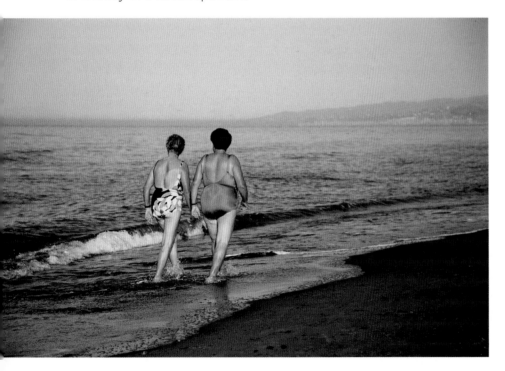

Beach ladies
I reduced the color saturation present in the original image to create a slightly more monochromatic effect.

(RIGHT)

Original image

I used a 35mm camera with a very long-focus lens and a wide aperture; the film was Fuji Provia 100.

(FAR RIGHT)

Waterbuck

I used the Rubber Stamp tool to remove the intrusive plant behind the animal's head and the foreground foliage.

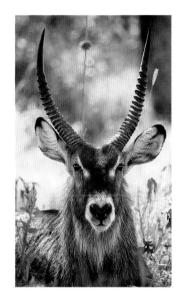

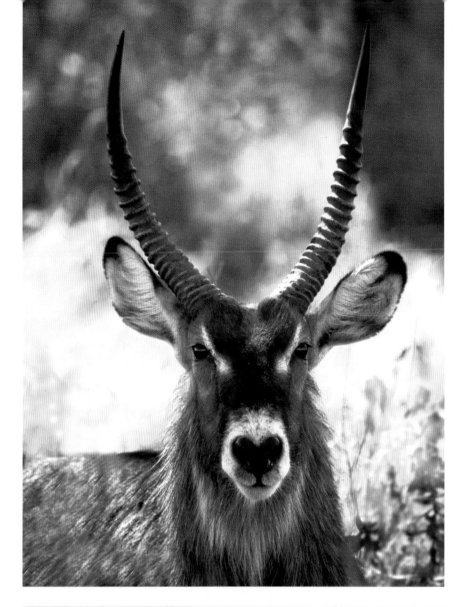

removing intrusions

I shot this picture of a waterbuck in the Nakuru National Park in Kenya from a quite close viewpoint, using a 600mm lens at a wide aperture. This usually renders the most obtrusive background details as a soft, out-of-focus blur, but the very prominent thistle quite close behind the animal's head was so strong that it became a distracting element. There was also some unavoidable foliage in front of the waterbuck, which made the image seem untidy.

I removed all of these unwanted elements using the Cloning tool set to Non-alignment. This allowed me to sample different parts of the soft, out-of focus background with which I replaced the offending thistle. In the case of the foreground foliage, I used the same method to sample areas of the fur to replace the foliage. However, using the Cloning tool in its Aligned mode when doing this type of retouching has the danger that a recognizable pattern can become discernible from the repeated cloning of adjacent areas.

TECHNICAL NOTE

The Dust and Scratches filter softens the image quite drastically. For smooth, plain tones with no detail, like a sky, a badly marked area can be selected using the Marquee tool and applying the filter to just this area. It will leave a noticeably soft, grain-free effect, but this can be disguised by adding a small amount of grain – Filter/Noise-Add Noise – until it matches its surroundings.

Another way of using Dust and Scratches is to apply it to the whole image and then, using the History Palette, check the box against this filter for the History Brush. By returning to the stage prior to applying the filter, you can use the History Brush to remove the blemishes, setting it to either Darken to remove light marks, or Lighten, to eliminate dark blemishes.

Adjusting Exposure

Photographers who shoot on negative film and make their own prints can control the final density and effect of an image. But those who normally use color transparency film are only too aware that the image is defined by the exposure they set at the time the picture is taken.

From a pictorial and creative viewpoint, the correct exposure is one that records a scene in the way that the photographer has visualized it, and even a small variation in exposure can make a significant difference to the quality and effect of a picture; this is the reason why many photographers who are shooting on color transparencies bracket their exposures, giving both more and less than the exposure meter indicates. But even this is a bit hit or miss, since the final effect cannot be seen until the film is processed.

With a digitized image it is possible to see the effect of varying the exposure on the computer monitor, and to make comparisons before deciding on the most effective setting. While it is often possible to produce good-quality images from transparencies that appear irretrievable, this can only be done if the information has been recorded on the film. A transparency that has been very overexposed, for instance, will show no highlight detail at all, and no amount of manipulation will restore it.

setting the black

As a general rule, photographs need to contain some areas that are completely black, and when using Curves or Levels it is possible to use the black eyedropper to establish a specific tone in the image as a pure black.

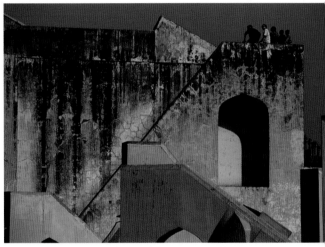

(ABOVE) **Original image**
This shot of the Royal Observatory in Jaipur, India, was taken using a long-focus zoom lens with a polarizing filter, on a 35mm camera loaded with Fuji Velvia film.

(LEFT) **Observatory**
The original image was almost one stop underexposed and looked very flat and degraded, but inspection with a magnifier on a light box revealed that there was adequate detail in the shadows so the photograph was well worth scanning and adjusting. I was able to do most of the adjustment using the Levels sliders on my scanner, and only needed to make small final adjustments using Curves in Photoshop.

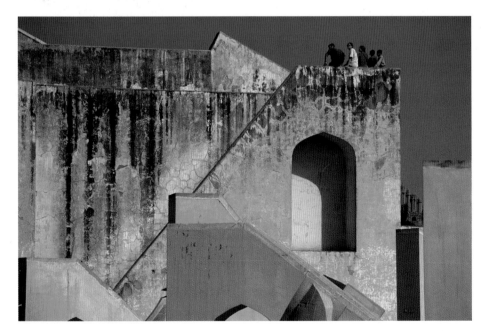

using curves

For this canal scene in Venice, Italy, I made a bracket of exposures on Fuji Velvia, finding that the one that was given a two-thirds stop less than my camera indicated produced the effect I wanted. I was interested, however, to see just how effective scanning and manipulating the image might be if I selected one of the overexposed transparencies. I chose one that had received one stop more than the one I preferred in the bracket, and found that by using the Curves control I could not only produce the rich colors that the much darker transparency had recorded, but could also improve the shadow and highlight details. To my surprise, I preferred the quality of this image to the one I had previously selected.

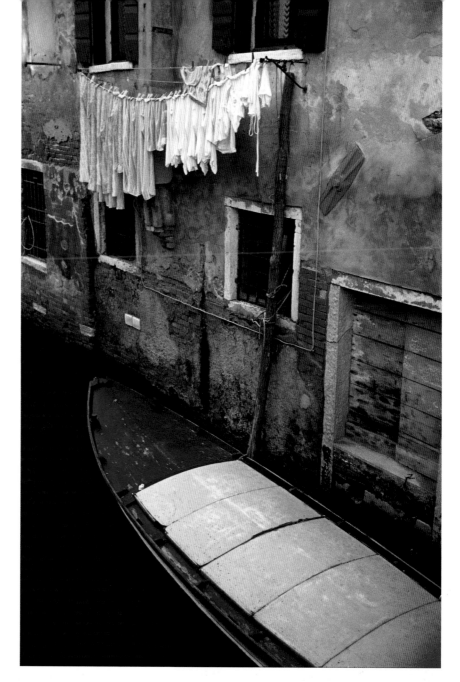

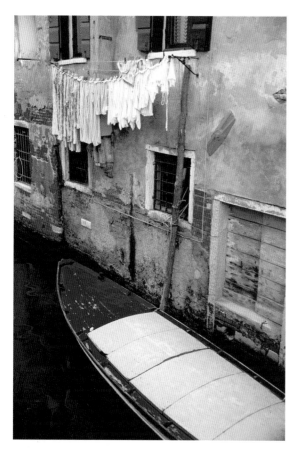

(ABOVE) **Pink boat**
Scanning and adjusting levels produced richer colors and a better tonal range.
(LEFT) **Original image**
The original transparency was about half a stop overexposed, which resulted in desaturated colors and a lack of highlight detail.

TECHNICAL NOTE

There are three ways of adjusting the exposure or image density using Image/Adjust. The Brightness/Contrast sliders are the most basic, but this is quite a crude control. Levels offers much more control over shadows, highlights and mid-tones; but the most subtle and flexible way of altering image density is by using Curves.

Contrast and Color Saturation

The quality of a photographic image is dependent upon the brightness levels of the subject or scene being photographed, and this is just as true of images recorded on photographic film as on a digital camera. If the brightness range of the subject is too high, detail will be lost in the highlight and shadow areas, resulting in a photograph that is harsh and unpleasing. If the brightness range of the subject is too low, there will be no solid blacks and the highlights will be veiled, resulting in a flat and lifeless image.

It is also important to appreciate that the acceptable brightness level of an image is also dependent upon the method by which it will be reproduced. The range of tones and colors recorded satisfactorily on a color transparency or computer monitor, for example, will be greater than those that can be reproduced on an inkjet print or the pages of a magazine.

Spanish poppies
I used the Levels adjustment on my scanner to increase the contrast initially, and then tweaked the image using Curves at the image-editing stage.

Original image
I photographed this scene using a 35mm camera, a long-focus lens and Fuji Velvia film, but the very soft light that prevailed at the time produced a transparency with inadequate contrast.

(ABOVE) **Original image**
Photographed on 35mm using Kodachrome 64 with soft lighting produced a transparency lacking both contrast and color saturation.
(RIGHT) **Red mountain**
Using a combination of Levels, and Hue and Saturation, allowed me not only to correct the degraded color quality of the original, but also to exaggerate it.

TECHNICAL NOTE

It is very difficult to judge image quality accurately on a monitor, especially contrast, unless you ensure that there is a minimum amount of ambient light in the room. At this stage of the editing, I have the room almost dark and use a hood to screen the monitor from any stray light.

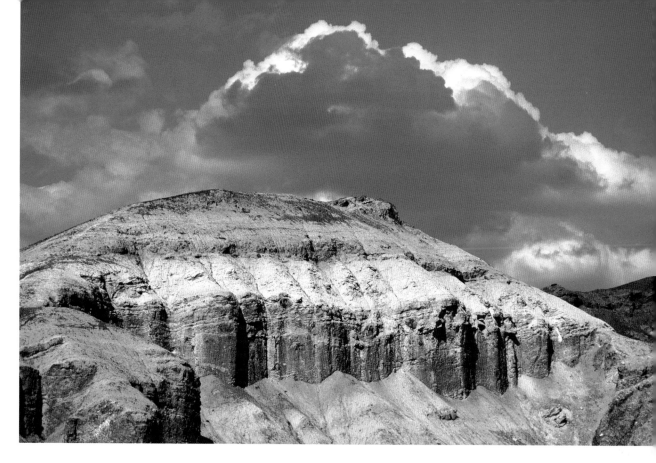

exaggeration for effect

ORIGINAL IMAGE I took this photograph some years ago in Death Valley, California, and was especially attracted by the cloud formation's bright rim of white and the way it echoed the shape of the mountain. However, the lighting conditions were far from ideal, since it was rather hazy and the sunlight had little edge. I shot the picture on the only film stock I had with me at the time, Kodachrome, a film that, in my experience, lacks the contrast and saturation that this scene really needed. I was, consequently, not too surprised to find that I was disappointed with the result.

ADJUSTING THE SKY After making basic Levels adjustments at the scanning stage, to produce good contrast and density, I made a selection of the sky area using a combination of Select/Color Range and the Magic Wand tool. I then used a combination of Image/Adjust-Hue and Saturation and Color Balance to produce a much cleaner, brighter blue, aiming more towards Technicolor than real life. I fine-tuned this and cleaned the whites using Image/Adjust-Levels.

ISOLATING THE ELEMENTS I next used Select/Inverse to isolate the mountain, and again used a combination of Image/Adjust-Hue and Saturation and Color Balance to create this rather exaggerated hue. These colors are not totally false, as even just increasing the contrast and color saturation of the sky and mountain revealed qualities that were not visible in the Kodachrome – I simply pushed them a little further.

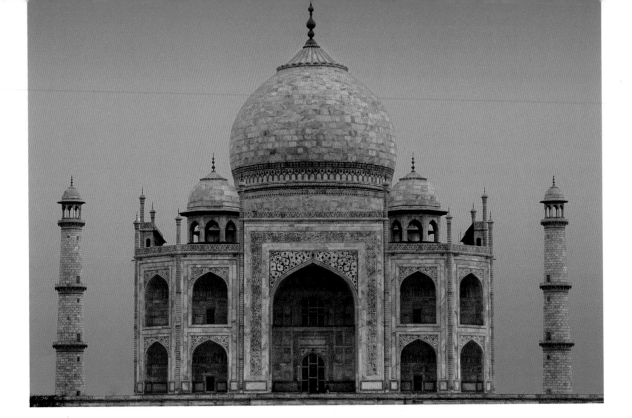

(RIGHT) **Taj Mahal**
Increasing the contrast and color saturation revealed a richer range of colors and tones, and increased the impact of the image.
(BELOW) **Original image**
I used a long-focus lens on a 35mm camera loaded with Fuji Velvia to shoot this dawn-lit image of the Taj Mahal.

working with soft light

ORIGINAL IMAGE The pollution levels in Agra, India, the location of the Taj Mahal, are such that even when the sun shines the light is quite often very soft. I took this photograph just before the sun came up, and the building looked absolutely beautiful because of the virtually shadowless lighting. But I was aware that the brightness range of the subject was very low and that there was unlikely to be enough contrast in the transparencies I had exposed using Fuji Velvia. Although I was quite pleased with the image, I decided to increase the contrast after scanning, to see if I could give it more impact and accentuate the subtle colors that had almost been lost in the original photograph.

INVERTING THE SKY AREA By increasing the contrast overall, using Image/Adjust-Curves, the sky became rather harsh in tone and started to look uneven. Using the Magic Wand tool, I carefully selected the sky area and then inverted the selection so I could increase the contrast on the building alone, also slightly increasing the color saturation by using Image/Adjust-Hue and Saturation.

TECHNICAL NOTE

The Curves control allows you to make very subtle changes to both the contrast and distribution of tones in the image, and by selecting the individual RGB channels you can make similar adjustments to the color balance. You can, for example, make shadows less blue while increasing the red content of the lighter tones and reducing the amount of green in the mid-tones. It is worth spending some time exploring the possibilities by selecting each channel in turn and altering the curves.

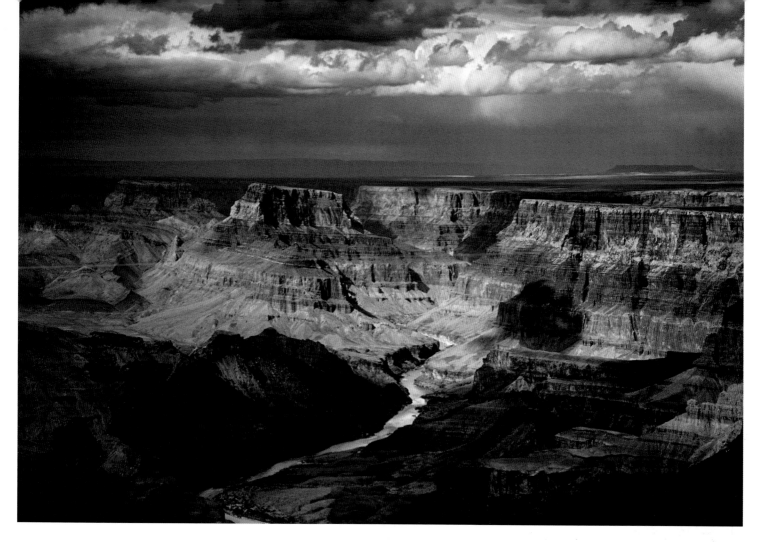

working with
low contrast

A big storm was brewing as I arrived at this viewpoint overlooking the Grand Canyon in Arizona. It was a spectacular sight and very atmospheric, but the little sunlight that still managed to evade the building clouds was now very diffused, and the contrast of the scene was very low. I was not surprised to find that the resulting transparency was rather flat and lacked any dense shadows.

Simply setting a black point and increasing the contrast using Image/Adjust-Curves improved the picture enormously, but I used the Graduation tool in conjunction with the

Quick Mask to create a graduated selection on the right-hand third of the frame, and used Levels in order to increase the contrast and decrease the density of this side of the image until it more closely matched the rest of the picture.

(ABOVE) **Grand Canyon**
Increasing the contrast overall using Curves and adjusting the left-hand side of the image to match the remainder has produced a more dramatic image.
(LEFT) **Original image**
Soft lighting has produced a flat image with little contrast on the 35mm Velvia transparency.

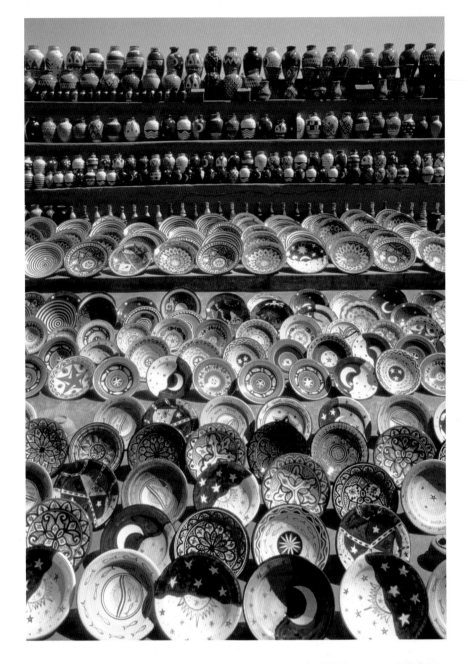

reducing contrast

Decreasing contrast is not as straightforward as increasing it, and the results are often less satisfactory. This is because when contrast is high, detail is lost in either the highlight areas or the shadows, or in both, and if this loss is significant, reducing the overall contrast of the image is not likely to restore it but will only make the image appear degraded. But there are other ways of improving the quality of the image if some detail in these areas remains.

decreasing shadows

DENSE SHADOWS The bright sunlight that illuminated this display of pottery in Morocco resulted in a brightness range greater than the film was able to record. Consequently the shadows are very dense, lacking both detail and color, and the highlights are burnt out.

OPENING UP THE SHADOWS I used the Curves control to make a basic adjustment to the contrast, which opened up the shadows a little and reduced the worst of the highlight glare. I next selected the shadow area using Select/Color range, and then used the Levels control to increase both the brightness and the contrast of the shadow areas.

DARKENING THE LIGHT AREAS Having selected the lightest tones in the image using Color Range, I made these a little darker using Levels. I then copied and pasted these areas into a new layer, desaturated it, and then set the Blend mode to Darken. This reduced the glare from the brightest highlights further.

(ABOVE) **Moroccan dishes**
Increasing the detail in the shadow and highlight tones of the scanned image using Levels produced a more pleasing image.
(RIGHT) **Original image**
Harsh sunlight produced a very contrasty transparency. It was exposed on 35mm Kodak Ektachrome 100 SW using a mid-range zoom lens.

capturing all the tones

ORIGINAL IMAGE I photographed this old Indian gentleman in open shade. The lighting was very soft, with only weak shadows, but his turban was such a bright white and his skin so dark that the film could not record both tones, and it became impossible to retain any detail in the turban without making the skin very dark indeed.

USING TWO SCANS To overcome this, I made two scans from the same, rather under-exposed transparency, which had some detail in the highlights. I adjusted one scan to give the maximum amount of detail in the white turban, and the other to give me a full range of tones in the face.

COPYING AND PASTING I then selected the lightest areas of the first scan using Select/Color range and copied it. After pasting this selection into the new layer on the image produced by the second scan, I made a mask of this layer and, using the Airbrush tool, painted out the areas where it was not needed, leaving the turban.

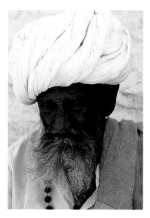

(ABOVE) **Original image**
I used a long-focus lens on a 35mm camera loaded with Fuji Velvia. In spite of the soft lighting provided by open shade, the transparency lacked detail in the highlight tones, and the skin tones were degraded.

(RIGHT) **Indian man**
Scanning the underexposed transparency twice, and combining the best areas of both scans, enabled me to create an image that held more detail in the white turban and a better range of tones in the man's face.

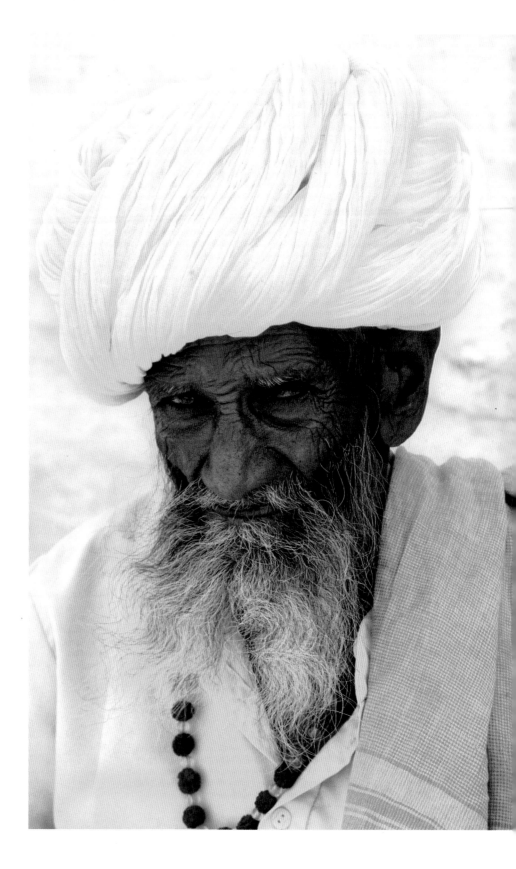

Focus and Diffusion

Modern camera lenses are capable of recording images with remarkable sharpness, and have the ability to accentuate detail and texture. But this is not always desirable, and techniques such as differential focusing and the use of long-focus lenses, wide apertures and soft-focus attachments are frequently used to soften or diffuse areas of an image, for example areas with a fussy background, or the skin texture in a portrait. With an image-editing program such as Photoshop, it is relatively easy to apply these techniques to a sharp image, with the advantage that the effect can be seen readily on the screen and varied according to taste. A further benefit is that the diffusion or blur can be applied to selected areas.

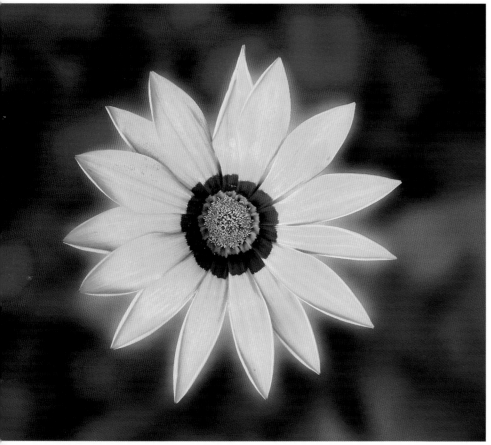

Flower
Creating a greater degree of diffusion on the background using Gaussian Blur gave the bloom more prominence and added impact to the image.

diffusing the background

I used a wide aperture for this close-up of a bloom, but even so the background was not rendered as softly as I would have liked. I first made a copy of the image on a separate layer and diffused it using Filter/Blur-Gaussian Blur, choosing a value that made the background appear much softer and less obtrusive. I then set the blend mode to Lighten, which created a slight halo effect, rather similar to placing a diffusing screen, such as a Softar attachment, over the camera lens at the time of shooting. I then made a mask for this layer and, using the Airbrush tool, erased the area inside the perimeter of the petals so the main part of the flower was no longer diffused.

Original image
For this close-up shot I used a long-focus lens with an extension tube on a medium-format camera, and set a wide aperture to throw the background out of focus.

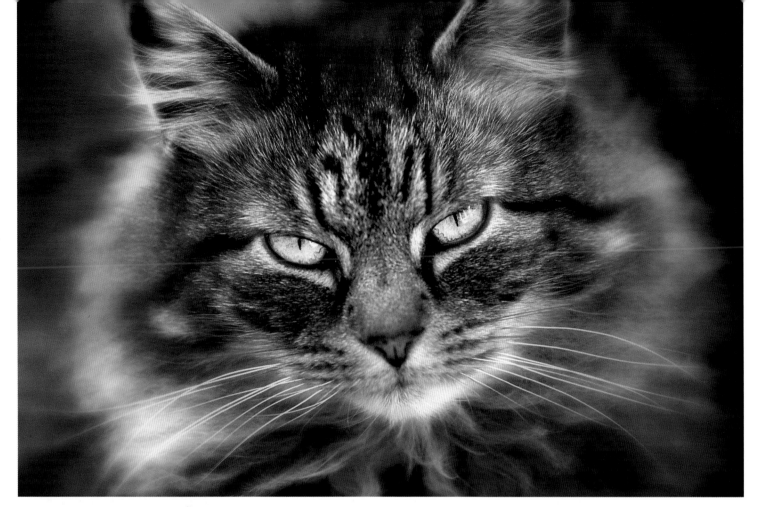

(ABOVE) **Cat**
Using Gaussian Blur to make the fall-off in sharpness even greater, and increasing the color saturation of the animal's eyes, gave the photograph a more eye-catching quality.

(LEFT) **Original image**
I used a long-focus lens with an extension tube to shoot this cat portrait on 35mm Fuji Provia, and selected a wide aperture to make the eyes and whiskers stand out more clearly.

exaggerating the focus differences

The depth of field for this close-up of a cat was quite shallow because I used a wide aperture, but I felt that the image could be given more impact if I made the fall-off in focus even more exaggerated. I used the Gradient tool to draw a circle around the center of the cat's face and then applied Gaussian Blur to a degree where the undiffused area of the image became much more prominent. A final touch was to select the eyes using the Magic Wand tool and then increase the Contrast, Brightness and Color Saturation, using Image/Adjust, until they took on this slightly sinister look.

TECHNICAL NOTE

When applying filters such as Blur, it can be a good idea to make a copy layer of the image to work on. Not only can it sometimes be effective to try different Blend modes, but you can also erase selected areas if necessary by applying a mask to this layer and airbrushing the effect out. Also, if you make a mistake or dislike the effect, this layer can simply be binned.

Improving Backgrounds

The cause of a disappointing picture is very often an untidy or unsuitable background, and this is sometimes beyond your control. The fault is frequently a distracting detail or color in a background area; but this can usually be corrected during image editing.

The previous pages have shown how techniques such as cloning over intrusions and using diffusion can be used to overcome some of these problems. But there are also other methods that can be employed, such as altering the color or tone of a background area to create a bolder contrast with a subject, and reducing the depth of field to give foreground details greater prominence.

TECHNICAL NOTE

The Magic Wand tool can be an effective way of selecting even areas with a quite complex outline: as you get closer to less well-defined edges, you increase the image magnification and, at the same time, reduce the tool's tolerance.

Original image
For this still life photographed in daylight I used an extension tube with a mid-range zoom lens, fitted to a medium-format camera. The film was Fuji Velvia.

lacking contrast

CRUDE COLOR I used a small section of my patio tiles for this still life of green pimentos, but felt, after seeing the transparency, that I'd made a bad choice, as the color on film seemed rather crude and unattractive and did not make the pimentos stand out as strongly as I had hoped.

DESATURATING THE BACKGROUND My first thought was to simply alter the color of the tiles by using Image/Adjust-Replace Color, but when trying this, I decided that I needed to make a more radical change. I used Select/Color range to select all the background colors and then desaturated just this area using Image/Adjust-Desaturate.

ADDING TEXTURE Next I used Color Balance to make the shadows quite blue by increasing both blue and cyan, and then increased the red and yellow a little in the highlights to give a pinkish tinge. With the background still selected I added a canvas texture using Filter/Texturize, and then added a small amount of Gaussian Blur to soften the effect.

Peppers
A bad choice of background was overcome by altering its tone and color, and adding a slight texture to create a more pleasing contrast with the green peppers.

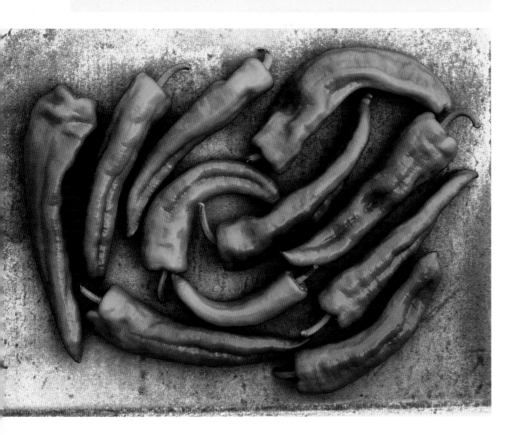

not enough separation

My cat, Tiffy, is a bit of a prima donna, and whenever I approach her with a camera she either turns her back or walks away. I caught her taking a nap in the conservatory one afternoon, looking very laid back and only partly awake. Because of her temperamental nature I had no option but to make do with the background of wall, which was less than ideal. I felt that the main problem was the fact that the background color was too similar to that of her fur to create good separation and visual impact.

CONVERTING FROM GRAY I used the Magic Wand tool to select the background area, and then used a combination of Color Balance and Hue and Saturation in Image/Adjust to convert the gray background to this orange-tinted hue, which provided a much more effective contrast to the fur color. I used the same method to give the cushion a slight blue tint.

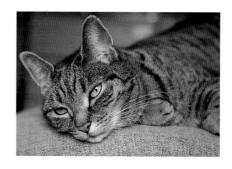

(ABOVE) **Original image**
I used a 35mm camera fitted with a mid-range zoom lens to shoot this animal portrait, taken in natural light using Kodak Ektachrome 100 SW.
(BELOW) **Sleepy cat**
I felt the original lacked impact because of the similarity between the animal and the background, so I selected this area and altered its color to create a stronger contrast between them.

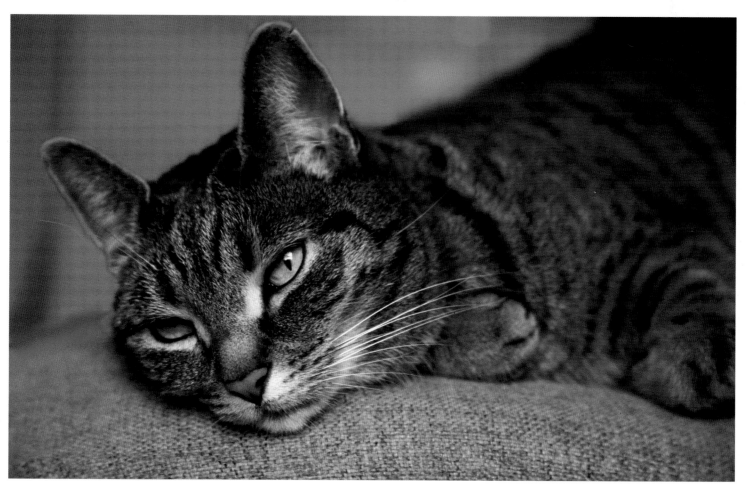

Improving Skies

As all landscape photographers know, the sky can make or break a photograph, and although filters such as polarizers and graduates can help to control this vital area at the time of shooting, there is a limit to what can be achieved in this way. Black-and-white workers have the advantage that skies can be burned in at the printing stage to obtain a better tonal range and more dramatic effects, but even this leaves something to be desired, as the shading almost always needs to be vignetted and the final effect inevitably looks contrived.

Pickwell winter landscape
I used a medium-format camera fitted with a wide-angle lens to produce a black-and-white negative, exposed on Ilford's XP2 film. I fitted a polarizing filter to create a better range of tones in the sky. Selecting this area after scanning and using Levels to make it darker has created a more dramatic image.

TECHNICAL NOTE

The Airbrush tool can be used both to build a mask and to remove areas of it by switching the angled arrows above the Foreground and Background Panels (which are set automatically to black and white when the mask is selected). With delicate areas, it helps to reduce the pressure of the airbrush and use it to build up density gradually.

revealing the drama

ORIGINAL IMAGE This winter landscape was photographed in North Devon, England, using Ilford XP2 black-and-white film. The negative showed very good detail in both the lightest and darkest areas of the scene, but when adjusted for basic levels the scan showed that the sky area needed about 300 percent more exposure than the dark foreground in order to reveal the rich and dramatic tones in this area.

DARKENING THE SKY I was able to make an accurate selection of the sky using the Magic Wand tool, and applied a very small amount of feathering to soften the edge. I then used Image/Adjust-Levels to make the sky area darker, simultaneously adjusting the contrast to achieve the density and tonal range I wanted the sky to have. The final step was to invert the selection and, again using Levels, I made the foreground a little lighter and slightly more contrasty.

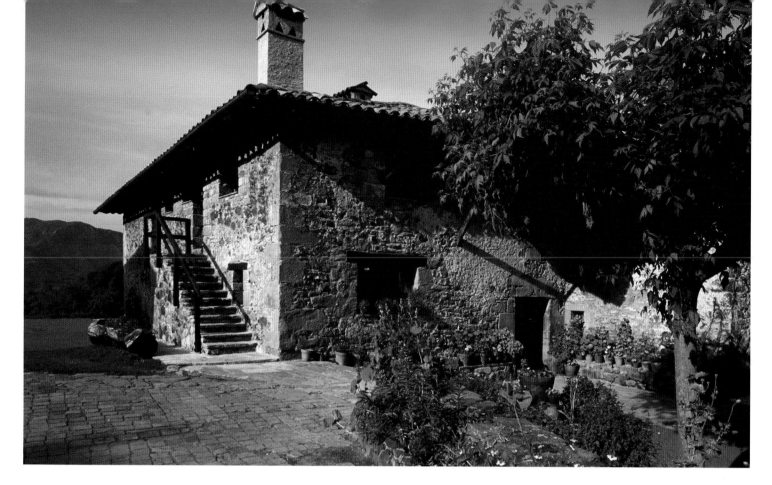

adding sky color

ORIGINAL IMAGE Soft summer sunlight in the late afternoon illuminated this old farmhouse in the Catalonia region of Spain very effectively, enhancing the texture and color of the old stone walls. Unfortunately, the pale milky sky rather spoiled the effect of the picture, and there was not enough color or detail in this area to overcome the problem in the same way as the previous image.

SELECTING THE COLOR I created a new layer and selected a foreground color by sampling the darkest blue I could find in the existing sky area. Using the Linear Gradient tool, I created a selection on the new layer running from the top of the image to about halfway down with the gradient set to Foreground to Transparent, and then selected Darken in the Blend mode.

USING THE AIRBRUSH This left the chimney slightly veiled, so I made a mask for the new layer and, using the Airbrush tool, erased this area of the blue gradient. The topmost area of the foliage is also slightly veiled but I felt that this was not too noticeable, and it would have been very difficult – but not impossible – to clean up in a similar way.

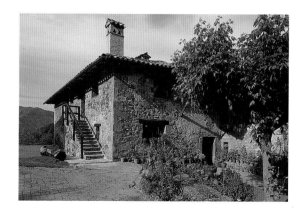

(ABOVE) **Catalan farmhouse**
The pleasant effect of the late-afternoon sunlight had been spoiled by the weak and colorless sky – improving this added to both the impact and the atmosphere of the photograph.

(LEFT) **Original image**
This building was photographed on a 35mm camera using a wide-angle shift lens and Fuji Velvia film. I used a polarizing filter to maximize the weak color in the sky.

Altering Perspective

The effect of perspective is an important factor in creating a sense of depth and distance in a photograph, and is created when the image includes objects or details of a similar size. It occurs because objects close to the camera appear much larger than those farther away, and the effect is exaggerated when a wide-angle lens is used.

But the effect of perspective can also have undesirable effects. A full-face portrait taken from a close viewpoint, for example, makes the subject's nose appear much larger than it really is and creates a distorted impression of his or her features. Yet another common problem is when the camera is tilted upwards to include the top of a building, as this makes vertical parallel lines appear to converge.

TECHNICAL NOTE

When you increase the size or alter the perspective of an image in this way, the increased number of pixels is interpolated (i.e., the gaps are filled in between the original image pixels), and consequently the definition is not quite as good. With moderate increases in image size this is not too apparent, but there is a limit beyond which image quality will be noticeably degraded.

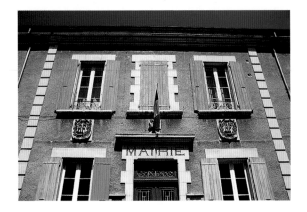

Original image
A restricted viewpoint meant I had to tilt the camera upwards to include the top of the building. The image was photographed on a 35mm camera using a wide-angle lens and Fuji Velvia.

eliminating convergence

ORIGINAL IMAGE Photographing the façade of this town hall in a small French village, I needed to tilt the camera quite a lot to include the top of the building. I felt that the steeply converging verticals detracted from the geometrical quality of the image.

SHIFTING THE PROPORTIONS I increased the canvas size a little to make room to expand the image, and then selected just the image using the Marquee tool. Using Edit/Transform, I selected Perspective and pulled the image so that the top corners moved outwards until all the verticals were parallel. This left the windows looking rather squat so, with the selection still in place, I changed the Transform mode to Distort and pulled the top upwards until the windows appeared to be in the right proportion. I also pulled the sides outwards to restore the image to more or less its original proportions.

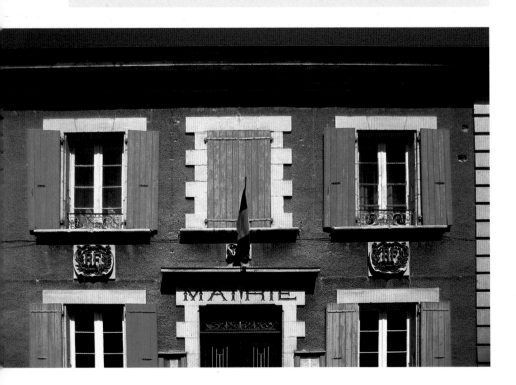

Mairie
The converging verticals, caused by the tilted camera, detracted from the symmetry of the image; correcting this produced a more pleasing effect.

increasing the effect of perspective

This fine old church is in the small French village of Clamecy, in Burgundy. The small square opposite provides a very restricted viewpoint, and the only way to include a substantial area of the building is to use a wide-angle lens with the camera tilted upwards quite considerably. I decided to make this a feature of the composition and used a very wide-angle lens together with a close viewpoint in order to exaggerate the perspective effect even further. But the resulting transparency still lacked the dramatic effect I wanted, so I used the same methods as the previous image, in this case to increase both the perspective and distortion of the church, until I was happy with the altered proportions.

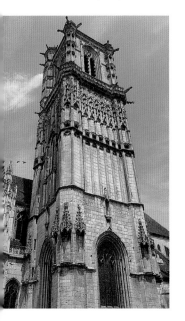

(LEFT) **Original image**
I deliberately chose a close viewpoint, a wide-angle lens and a steeply tilted camera to create the exaggerated perspective effect of this shot, taken on 35mm Velvia.
(RIGHT)
Burgundy church
For a more dramatic effect I used Edit/ Transform to increase the steepness of the converging verticals, and to create greater perspective distortion.

Adding an Element

Just as cloning, together with copying and pasting pixels, can be used to remove unwanted objects or details, the same technique can be used to add to an image. There are occasions when an image needs something extra to balance the composition or to add interest to a picture, and this can often be achieved by adding an element from another image, or repeating one already within in it.

TECHNICAL NOTES

When adding an element to another image, it is important that both the lighting and color quality of the two images are compatible if the result is to be naturalistic and convincing.

unbalanced composition

ORIGINAL IMAGE I saw this old hotel in a small village in northern France and was greatly attracted by its ancient weathered façade, the lettering and the shuttered windows. I photographed it from across the street, framing the image in a way that created a symmetrical, patterned effect. However, the lack of a window above the door seemed to me to unbalance the composition and gave the impression that a shutter was missing.

COPYING AND FITTING The problem was easy to rectify. I simply selected the shutter nearest to the gap using the Marquee tool with a small amount of feathering. I then copied this area and moved the selection so that it sat comfortably in the gap and lined up with the other shutters. After pasting it in, I flattened the image and then tidied up any tell-tale signs of my handiwork using the Rubber Stamp.

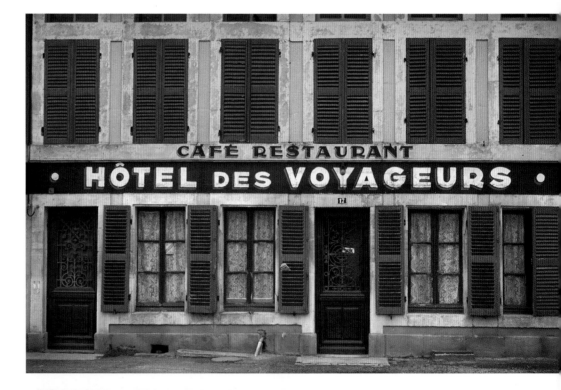

(ABOVE) **Hôtel des Voyageurs**
Adding the "missing" window has helped to create a more balanced and symmetrical composition.
(LEFT) **Original image**
I used a 35mm camera fitted with a mid-range zoom lens and loaded with Fuji Velvia for this shot. I chose a frontal viewpoint to create a symmetrical effect.

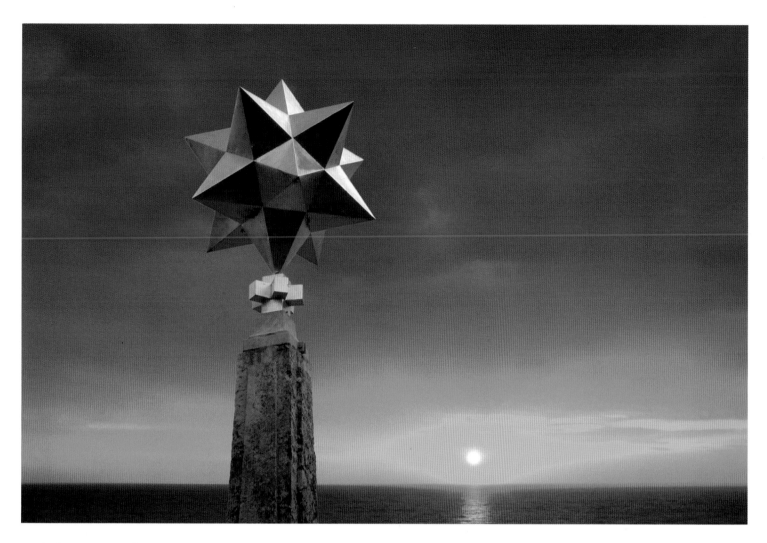

adding a focal point

BACKGROUND IMAGE There are often occasions when there is a stunning scene in front of the camera but no real focus of interest. I watched this beautiful sunset evolve while I sat on a terrace on the Costa del Sol. I looked hard for something eyecatching that I could use as foreground interest, but without luck. The colors appearing in the sea and sky were so spectacular that I photographed it anyway, on the grounds that I might be able to use it as a background to another image at a later date.

READYMADE IMAGE The obelisk marks the location of Château Mouton Rothschild in France, and I photographed it more recently, as I thought it might be useful sometime in a combined image. On searching through my files, this sunset seemed a possibility.

PUTTING THE TWO TOGETHER I selected the obelisk using a combination of Select/Color Range, Magic Wand and Quick Mask, and applied a very small amount of feathering before copying it and pasting it onto the sunset image. I used Edit/Transform to adjust the size, and Image/Adjust-Curves to modify its tonal range and color quality until I felt it looked compatible with the background image.

Sunset star
Two 35mm color transparencies, taken at different times and in different places, were used to produce this combined image.

Altering Color Balance

One advantage held by digital cameras over film-burning ones is that they adjust automatically to the color quality of the lighting. But those using film must ensure that the film is balanced for the light source – i.e. using tungsten film in artificial light – or by using filters in order to compensate for any differences. However, by scanning a color transparency it is possible to make very precise and selective adjustments to the color balance of an image, and sometimes this can be desirable even with a digital camera.

Original image
I used a wide-angle shift lens, a 35mm camera and Fuji Velvia film to photograph this church interior. It was illuminated by a mixture of artificial light and daylight.

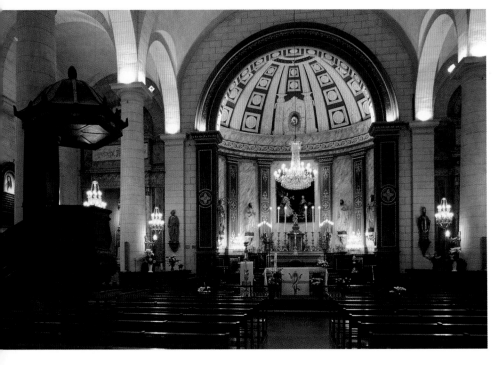

Church interior
Correcting the orange color cast created by the artificial lighting created a more natural and pleasing effect.

strong color cast

ORIGINAL IMAGE Very often when shooting scenes lit by artificial lighting, it is impossible to be certain if a color cast is going to result without the use of a color temperature meter. This scene, the interior of the church at Pauillac in south-west France, was lit by a variety of different sources, including daylight, and I used transparency film balanced for daylight. I felt the pronounced orange cast this produced in some areas was far too strong, and I scanned the transparency so I could change it.

REDUCING THE CAST I used Image/Adjust-Curves to set the basic density and contrast of the image, and then used the mid-tone eyedropper to sample a section of the stone wall, which was almost neutral in color. This produced a much more balanced result, but I decided to modify it further by using Image/Adjust-Replace Color, sampling the color I wanted to modify and altering Hue and Saturation.

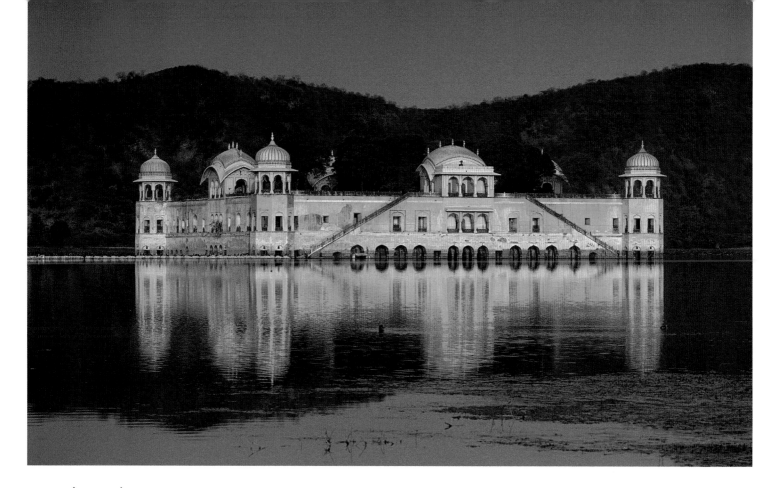

weak colors

When photographing subjects such as land-scapes and architecture, sunlight in the early morning or late afternoon can be extremely effective, partly because of the mellow, orange-tinted quality of the light, which can add a great deal of atmosphere to an image and give it a striking visual impact. For this picture of the Water Palace in Jaipur, India, I waited until the sun had almost gone down before taking my photographs, anticipating that it would bathe the building in orange-tinted light and contrast very effectively with the blue of the lake and sky.

Unfortunately the atmosphere was very hazy, and some time before the sun reached the horizon it lost much of its strength, weak-ening the effect considerably. In addition, the atmospheric haze caused the sky and water to

look more gray than blue, and consequently my transparencies were rather disappointing. **BOOSTING THE COLORS** After adjusting the basic density and contrast of the scanned image, I selected the building using Select/Color range. In Image/Adjust-Hue and Saturation I was able to increase the orange-tinted effect of the light until it showed the quality I had hoped for in nature. I then inverted the selection and, again with Image/Adjust-Hue and Saturation, I made the sky and water a richer blue.

Original image
This scene was shot on a 35mm camera, fitted with a mid-range zoom lens and loaded with Fuji Velvia film. Evening sunlight created a pleasing lighting quality, but atmospheric haze caused the colors to appear weak and degraded.

Water Palace
Increasing both the contrast and color saturation, using Levels and Hue and Saturation, added both impact and atmosphere to this image.

Using Controls Selectively

While using things such as color-balancing filters, graduated filters and bracketing exposures can go some way to controlling the density, color and tonal range of an image at the time of shooting, it can be seen that these methods are both crude and rather hit and miss compared to the way in which a digitized image can be controlled. Using digital control, the ability to make numerous changes to precise areas of a scene gives the digital worker the means of producing a successful photograph in situations where a normally exposed image would not.

too much density

ORIGINAL IMAGE I photographed this scene in the Andalucia region of Spain, making a bracket of exposures, but the one with the best composition was about half a stop underexposed and looked a little flat and dense. I corrected this using Image/Adjust-Curves and then looked at other aspects of the image that could be improved.

BRIGHTENING THE SUBJECT The horse was very dark with very little detail so I selected this area using the Magic Wand and, using Image/Adjust-Levels, increased both the brightness and contrast of this area. I had used a long-focus lens with a wide aperture but, even so, both the immediate foreground and the background were sharper than I would have liked.

DIFFUSING THE SURROUNDINGS I made a graduated selection, using the Linear Gradient Tool and Quick Mask, of each area in turn and applied a degree of Gaussian Blur until they became more diffused. I used the Rubber Stamp tool to clone over the still-visible section of wire fence in the foreground, and slightly increased the overall color saturation.

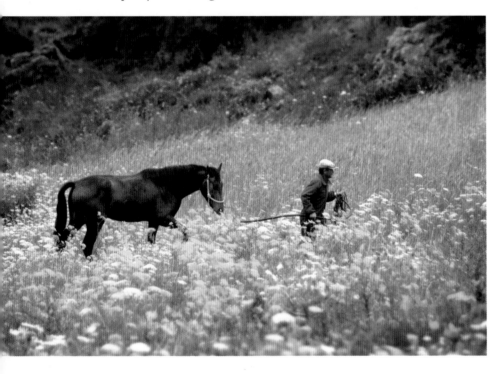

(ABOVE) **Spanish horse**
Adjusting Levels and making alterations to selected areas improved the quality of this image.

(TOP RIGHT)
Original image
A slightly underexposed 35mm transparency, shot on Fuji Velvia, resulted in an image that suffered from blocked-up shadows and degraded colors.

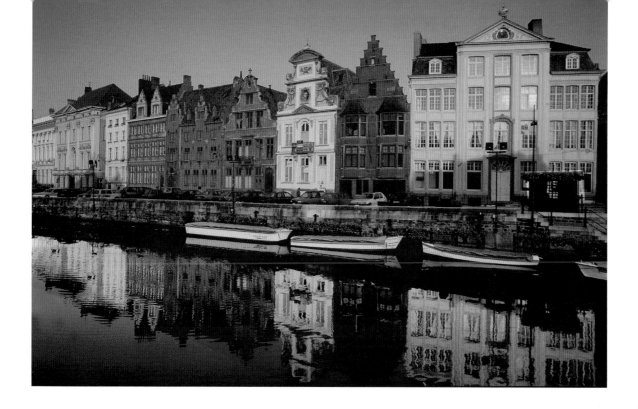

Ghent
The use of Levels and Hue and Saturation in selected areas of the image has improved its quality and impact.

dull reflections and bland sky

ORIGINAL IMAGE I shot this canal-side view of old houses in Ghent, Belgium, in the early evening, when the sunlight had created a particularly pleasing color quality. Even so, having chosen the best transparency from the bracket and using filters to their best advantage, I was disappointed. My main concern was that the reflection of the façades in the water was so dark and dull, but I also disliked the rather degraded color of the sky.

INCREASING OVERALL COLOR After scanning and making basic Levels adjustments, I used Image/Adjust-Hue and Saturation and then Levels to increase the overall color saturation of the image and to add some red to the highlights. I then used the Magic Wand to select the sky area. With Image/Adjust-Hue and Saturation I altered the sky color to give me a purer, cleaner color, and with Linear Gradient/Quick Mask in combination with

Image Adjust/Levels I also made the sky a little darker towards the top of the frame.

ADDING A PATH Using the Pen tool, I created a path along the waterline and converted this into a selection with a small amount of feathering. Using Levels I increased both the brightness and the contrast of the reflections to a convincing degree and, using the same selection, used Color Balance to make the color quality of the reflections appear much closer to that of the houses.

LOSING OBJECTS There was a rather distracting part of a boat visible in the bottom left corner of the frame, so I selected a similar-sized adjacent area of water reflections and, with a small amount of feathering, copied and pasted this over the offending detail, making good any visible joins with the Rubber Stamp. The white car in the center of the image was also rather distracting, so I selected this area using the Magic Wand and then, using Levels, reduced the contrast and density until it became less obtrusive.

Original image
Evening sunlight created a pleasing effect in this shot of old canal-side houses, but the color of the sky is degraded and the reflections are rather dull.

Taking the Image Further

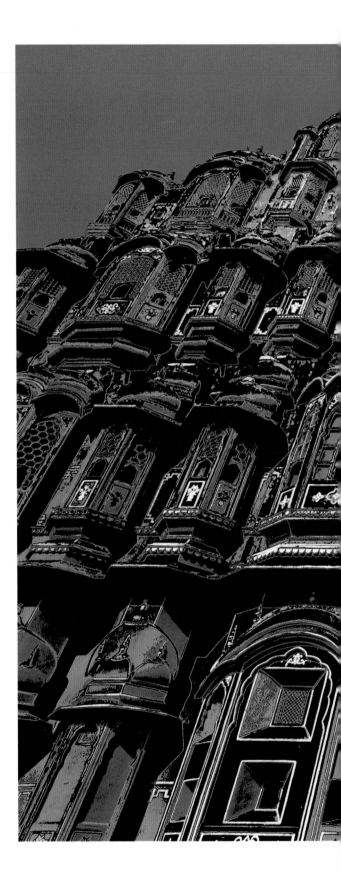

"The camera never lies" is essentially true in so far as a camera records quite objectively the subject or scene upon which it is focused. Any difference there might be between the image and the original scene is a result of the photographer's intervention, or the shortcomings and characteristics of the recording medium.

Many of the photographs taken every day are designed to provide information, and it is important that they are as faithful to the original subject as possible. Some gilding of the lily is desirable for other uses of the medium, such as food, beauty and product photography, but these even pictures usually remain essentially true to the original subject.

But when photographs are shot purely for personal and artistic motives, it is often an important part of the creative process to distance the image so it is more than a straightforward record of a scene. A photographer using the digital process today has more opportunity to do this than at any time in the medium's history.

Palace of the Winds
I used some of the techniques described in this chapter to radically alter both the tonal range and colour content of this image.

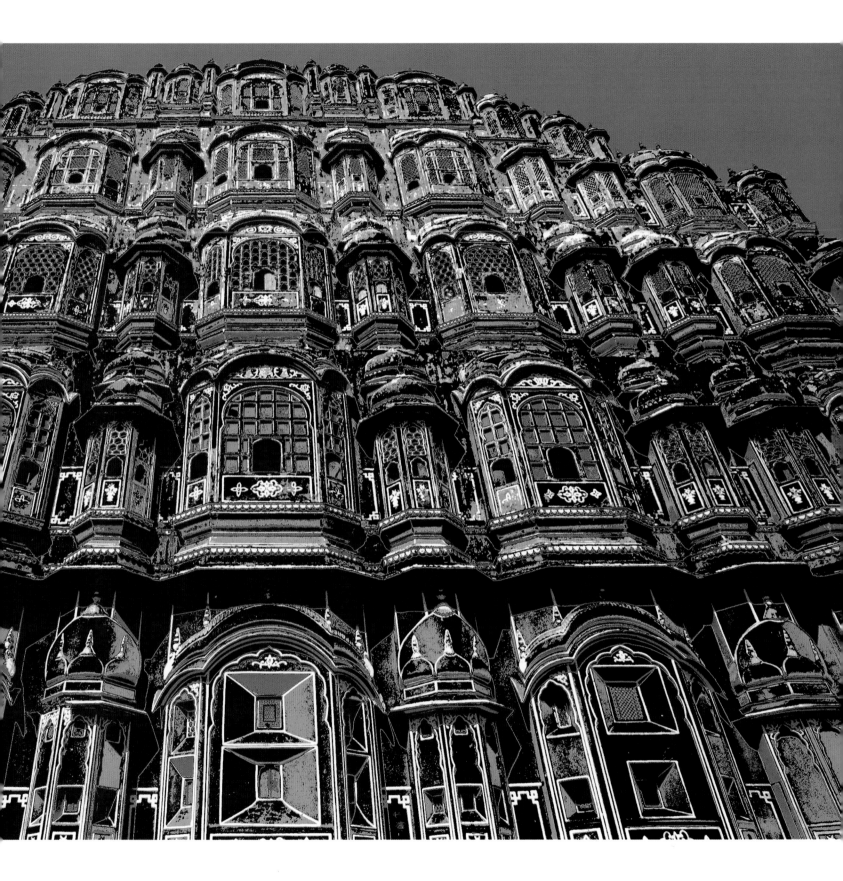

Color into Black and White

Prior to the onset of the digitized image, most photographers had to make a choice between shooting in color or in black and white. Like many others, I carried an additional camera body loaded with black-and-white film for those occasions when I needed it. Although it was possible to make black-and-white prints from a color transparency, this was a big compromise on quality, as a copy negative had to be made first, and black-and-white prints made from a color negative required the use of special black-and-white paper.

An image recorded digitally or scanned from color film can be converted into a black-and-white image that has just the same photographic quality as it would have in color. I frequently shoot pictures on color transparency film with the intention of using the image in black and white. This is not because I am too lazy to carry a separate camera body and extra film stock, but because I can have much more control over the tonal range of the image than if I used black-and-white film.

(BELOW LEFT)
Original image
I photographed this scene on a 35mm camera using a long-focus lens and Fuji Velvia film. I used a polarizing filter to intensify the color of the blue sky.
(BELOW)
Hastings fishing boat
A straightforward color to Grayscale conversion produced an image with a limited tonal range.

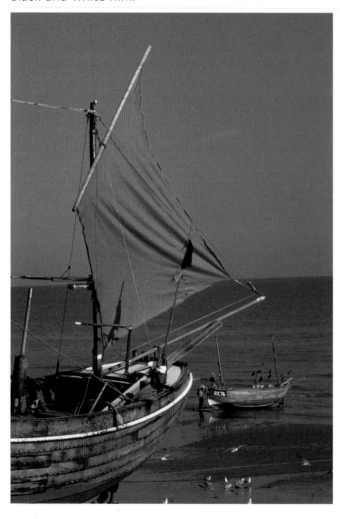

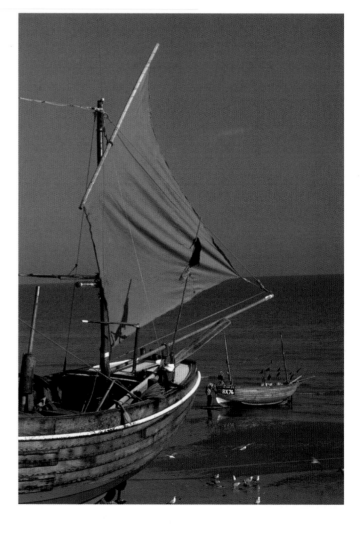

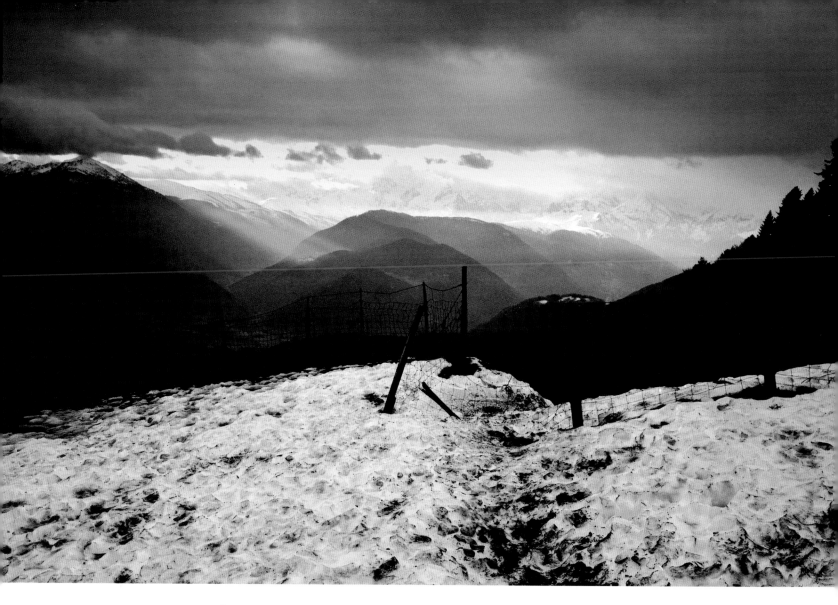

tone versus color

The one factor vital to producing good black-and-white images is the ability to differentiate between tone and color. Even experienced photographers tend to dislike having to shoot both color and black-and-white pictures on the same assignment, because the way of viewing a scene or subject needs to be so different.

Imagine a subject that contains bright, contrasting colors, green apples in a red bowl on a blue tablecloth, for instance. As a color photograph this would be a bold and vibrant image, but in black and white it would be flat and lifeless. This is because although the colors of the apples, bowl and cloth create a bold contrast, tonally they are very similar. Consequently, in order to produce good black-and-white images you must learn to see only the tones inherent in a scene and to ignore the colors.

Ideal black-and-white subject

This scene is the type of subject that works very well in black and white because it contains a full range of tones, from a rich, juicy black, through subtle shades of gray, to pure white.

Original image
I photographed this scene on a 35mm camera with a mid-range zoom lens and Fuji Velvia, using a polarizer and an 81B warm-up filter to intensify the colors.

using the channel mixer

It might seem that all you need to do when converting an image from color into black and white is to change from RGB to Grayscale in Image/Mode, and in many cases, when the subject has a good range of tones, this will be perfectly satisfactory.

However, a better way of converting an image from color to black and white is to use Image/Adjust-Channel Mixer. By checking the monochrome box and moving the red, green and blue sliders you can increase or decrease the density of these individual layers within the same image. This is a similar principle to using colored filters with black-and-white film to control its sensitivity to a particular color, except that on a camera you can only use one filter, whereas in Channel Mixer you can achieve the effect of using several different colored filters simultaneously. Once you have achieved the best effect, you can convert the image to Grayscale in order to reduce the file size.

dramatic color

ORIGINAL IMAGE This picture, taken in the Spanish Alpujarra mountains, has a very bright, quite punchy quality as a color image, but a straight conversion from RGB to Grayscale resulted in a flat and muddy, almost indecipherable picture. I wanted to create the same visual impact in the black-and-white version as existed in the color one, with the poppies standing out in bold relief from the rest of the image.

BRIGHTENING AND LIGHTENING By going to Image/Adjust-Channel Mixer and checking the monochrome box I was able to make the red poppies a much lighter tone by increasing the brightness of the red layer. I also lightened and added contrast to the green foliage by increasing the input of the blue and green channels. The resulting image shows a much fuller range of tones and produces a photograph with a livelier and more pleasing quality.

Poppies
(ABOVE RIGHT) *A straightforward Grayscale conversion produced a black-and-white image that lacked the contrast and impact of the original.*
(RIGHT) *Using the Channel Mixer allowed me to alter the tonal range and produce a more punchy image.*

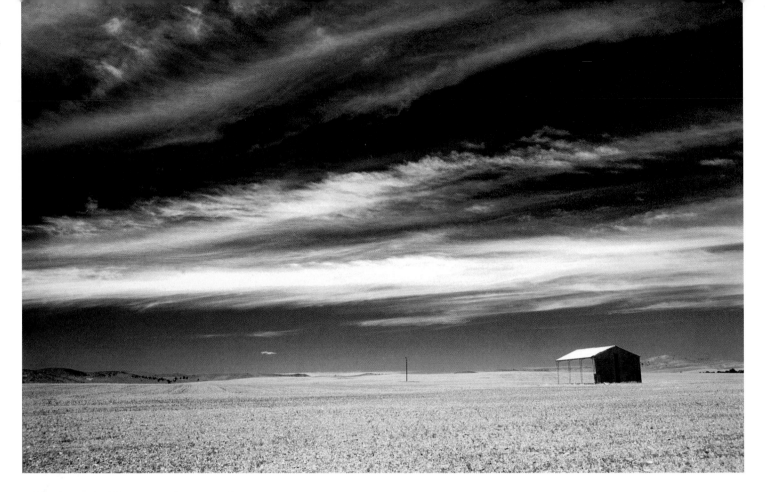

(ABOVE) **Outback**
Using the Channel Mixer instead of making a straightforward Grayscale conversion allowed me to create richer tones in the sky and a more dramatic quality in the overall image.

(LEFT) **Original image**
I photographed this scene using a 35mm camera fitted with a wide-angle lens and a polarizing filter; the shot was exposed on Fuji Velvia.

infrared-style image

ORIGINAL IMAGE Use of the Channel Mixer can be extended to creating quite dramatic changes to the tonal range and impact of an image. I took this photograph in South Australia, and it was the cloud formation in the sky and its juxtaposition with the small isolated building that interested me. I used a wide-angle lens and framed the image in a way that created the most dramatic effect, and in order to enhance this further I used Fuji Velvia film and a polarizing filter to give the blue sky a darker and richer tone.

MIXED BLACK-AND-WHITE IMAGE Although I was quite pleased with the result, after scanning the color transparency and increasing the color saturation, I decided to see the photograph as a black-and-white image. But when I converted it to Grayscale, the blue sky was not dark enough for my liking.

WORKING ACROSS THE COLORS By using Channel Mixer and decreasing the brightness of the blue channel and increasing both the green and red, I was able to produce a range of tones that are not dissimilar to those that could have been achieved using infrared film with a deep red filter: an almost black sky with very white clouds and bleached-looking grass.

(LEFT) **Original image**
I photographed this leaf using a 35mm camera with a macro lens and Fuji Velvia film.
Leaf (BELOW)
A straightforward Grayscale conversion produced a black-and-white image holding little of the original's impact.
(RIGHT) *Adjusting the sliders in the Channel Mixer, with the monochrome box checked, produced richer tones and a more dramatic quality.*

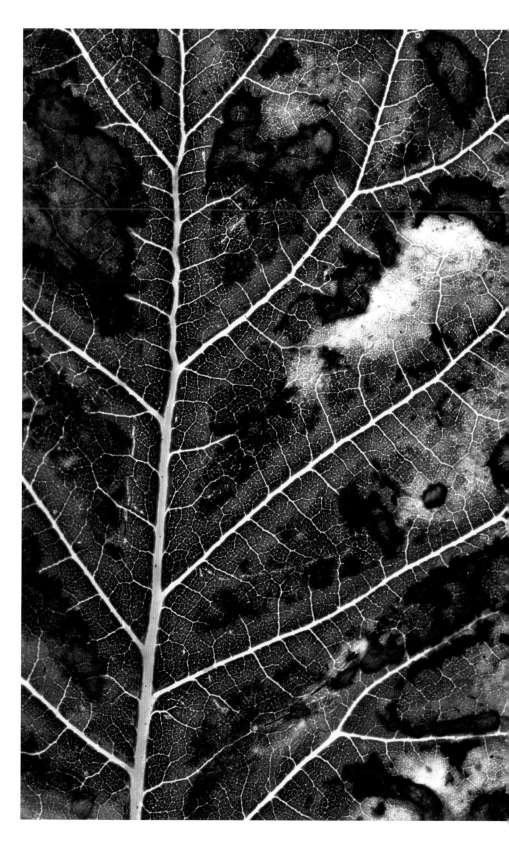

Altering Tone and Color

We saw in Chapter 2 just how effectively image-editing software can be used to improve the quality of an image in a way that is undetectable; but these and other techniques can also be used in a much more obvious way to enhance specific image qualities and to produce effects that can add to the interest of an image and create greater impact.

increasing contrast

ORIGINAL IMAGE I took this portrait on a beach in Tobago, West Indies. I shot the picture in the shade of a beach umbrella to avoid the harsh quality of direct sunlight, and the resulting skin quality had good texture and detail. But the image lacked impact, and I decided to scan the transparency and explore the possibility of increasing the contrast to achieve this.

BLEACHING OUT Using Image/Adjust-Curves, I made the RGB curve much steeper, which resulted in the skin tones taking on a much more punchy quality and the lighter tones of the image being completely bleached out. I could accept the latter, but the extra contrast also increased the color saturation. Using Image/Adjust-Hue and Saturation, I altered these factors until I obtained the color I wanted.

Conch man
I took the original portrait using a 35mm camera fitted with a long-focus lens, using Kodak Ektachrome 100 SW. I then increased the contrast to produce a more dramatic quality.

strong colors

I was attracted by the vivid color of this house in a small New England village and its contrast with the green foliage and blue sky. There was something about the scene that reminded me of an old-fashioned postcard, and I decided to get a little of this quality into the image.

INVERTING COLOR SELECTION I used Select/ Color Range to isolate the house and the red flowers in the foreground, and then inverted the selection. In Image/Adjust I went to Desaturate, rendering the remainder of the scene as a black-and-white image. Using the History Brush, set to a low opacity, I painted back just some of the color in the grass, leaves and sky. I then selected the sky area using Select/Color Range and filled it with this rather dusty shade of gray-blue. I finally fine-tuned the colors individually, using Image/Adjust-Replace Color.

(ABOVE) **Original image**
I photographed this scene using a medium-format camera fitted with a wide-angle lens and Fuji Velvia.
(BELOW) **Red house**
Altering the Hue and Saturation of the background produced a more interesting color quality.

other tonal techniques

There are a variety of ways in which the tonal range and the color quality of the image can be changed, in addition to the normal method of using the Color Balance, Levels and Curves controls. It can also be interesting to combine some of these methods and to use facilities such as Layers and Blend modes as well as Replace Color and Color Range selections.

ORIGINAL IMAGE I photographed this rock formation in the soft light of open shade, as the reflections in the wet surface were creating a good tonal range and contrast. I shot the subject on color transparency film, although my intention was to use the image in black and white, and the result was almost there. But I decided I would also explore the possibility of exaggerating the colors inherent in the subject.

ADJUSTING THE OPACITY Simply increasing the color saturation produced a rather crude and garish image, so I decided to make a duplicate layer of the original scan and then increased both the contrast and color saturation of this layer considerably, using Image/Adjust-Levels and Hue and Saturation. By setting the blend mode to Saturation and adjusting the opacity, I produced an effect that combined the tonal range of the original image with an exaggerated version of the colors.

Original image
I used a 35mm camera fitted with a mid-range zoom lens and Fuji Velvia film to photograph this rock.

Shiny rock
I used Layer effects, in combination with Levels and Hue and Saturation, to increase the color saturation.

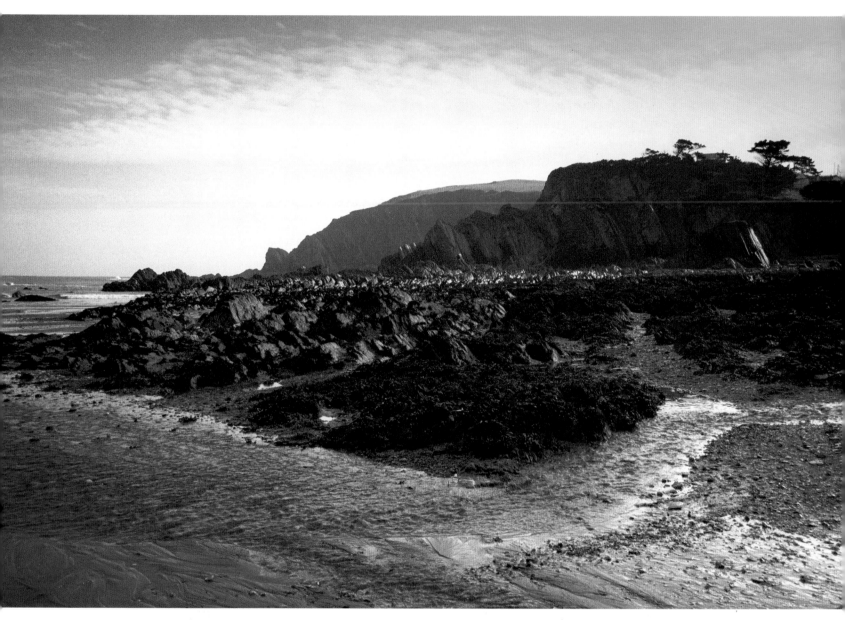

exaggerating blues

It was a very hazy day when I took this photograph of Lee Bay in the North Devon region of England. I used a fast color negative film for the shot, and the proof prints had a blue cast as a result of the lighting conditions. Instead of correcting this after scanning, I used Image/Adjust-Color Balance to exaggerate it, and Replace Color to fine-tune it to the shade of blue I wanted. This left the image without any blacks but because I did not want to increase overall contrast, I used Select/Color Range to isolate its very darkest tones, and then with Image/Adjust-Levels I increased both the contrast and the density of these tones, thus giving the image a little more bite.

Lee Bay
I shot this on Fuji Superia 800 color negative film using a 35mm camera and a wide-angle lens. I've exaggerated, rather than reduced, the inherent blue cast caused by the lighting conditions to enhance the image's mood.

using posterization

In Image/Adjust, the Posterization mode allows you to reduce the number of tones and colors in which the image is rendered. Using this, you can make the graduation from light to dark a series of abrupt steps instead of a smooth seamless progression, and given the right subject, the results can be very effective.

Although at first glance this facility may appear to give a fixed and regulated effect, you can, in fact, have quite a lot of control over it by altering the density and contrast of the image to which it is applied.

altering hue and saturation

I took this shot in Venice, Italy, shooting into the light, and I felt that the colors were a bit too subdued and the water was a rather unattractive gray. After scanning I adjusted the levels so as to give me a fairly light image without too much contrast, and then used Image/Adjust Posterization set to a level of 4. This produced a quite pleasing effect, but the color of the water was still not to my liking. Using Image/Adjust-Replace Color, I altered the hue and saturation of this area. The overall effect was a little too harsh, so I made a duplicate layer and applied a small amount of Gaussian Blur, using the Filter menu, and then set the Blend mode to Lighten.

Gondolas
I used a 35mm camera fitted with a mid-range zoom lens and Fuji Velvia film. I applied the Posterization effect to enhance the color content of what was a rather gray scene.

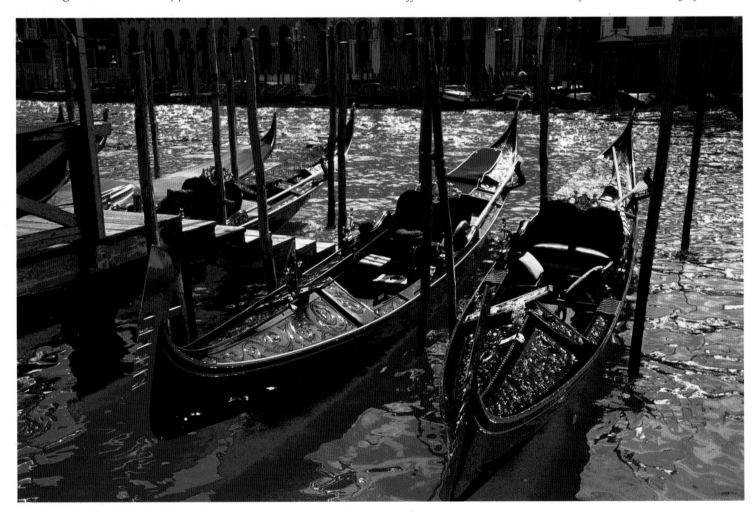

Making a duplicate layer

For this image I also set the Posterization level to 4 and made a duplicate layer to which I applied Gaussian Blur, setting the Blend mode to Lighten. I then made a mask for this layer and, using the Airbrush, painted out the central part of the bloom to reveal the sharper image below. I finally made some adjustments to the background colors by using Image/Adjust-Replace Color.

Changing the background

In this case I made a duplicate layer of the original image and posterized this using a level setting of 2. I then set the Blend mode to Exclusion and adjusted the effect using Levels. After flattening the image, I made a final adjustment to the contrast and density using Curves, and tweaked the background color using Image/Adjust-Replace Color.

combining effects

There are so many ways of altering the tone and color of an image using image-editing software that the permutations are virtually endless when combined with the limitless variations of a subject and its tonal and color qualities. The fascinating thing about digital effects is that one particular technique can produce a pleasing effect in one situation but not in another that appears very similar. Serendipity often plays a large role in my image-making, and I frequently make happy discoveries when experimenting.

adding drama

I shot this picture because the shape of the leaning tree trunk appealed to me. The light was quite soft, and I felt the resulting transparency was a bit bland and had little density or color in the sky. My first attempts at improving the image were focused on making the sky a darker and richer color, but when I increased its density by selecting it and altering the levels, it took on a coarse and unattractive quality. I had made a duplicate layer in order to do this and tried various Blend modes, and found to my surprise that I liked this effect when it was set to Exclusion; this was partly because the sky was now very dramatic and much more interesting, but also because there were still some natural colors and tones in the foliage.

Masai tree
This scene was photographed in the Masai Mara in Kenya using a 35mm camera with a wide-angle lens and Fuji Velvia film. I introduced the effects described on this page to overcome the bland and uninteresting quality of the sky in the original photograph.

ORIGINAL IMAGE I shot this picture in the vineyards of the Medoc region in France late one afternoon, and was attracted by the shape of the winding road and the light glancing off its surface. But it was not late enough for the sky to have much color, and the transparency seemed a bit lifeless and too monochromatic. And although I used a graduated filter, the sky was rather too light in relation to the foreground.

DARKENING AND INCREASING CONTRAST After scanning and making basic Levels adjustments, I made a duplicate layer and, using Curves, made the whole image darker and created this range of colors in the sky. I then set the Blend mode to Darken. Next I made a mask for this duplicate layer and painted out the foreground details so the

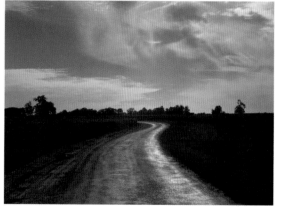

lighter tones of the base layer showed through. Before flattening the image, I made some final adjustments to the foreground by increasing the contrast of the base layer, and then I fine-tuned the colors in the sky by using Image/Adjust-Replace Color in the top layer.

(ABOVE) **Winding road**
Introducing color into the sky made this picture more interesting and gave it additional impact.
(LEFT) **Original image**
This photograph was taken on a medium-format camera fitted with a wide-angle lens and a graduated filter; the film was Fuji Velvia.

Taking the Image Further • 71

using replace color

One of the most useful, and sometimes more entertaining, features of digital image control is the ability to alter individual bands of color in a photograph. This can be done in a very subtle way, to overcome the inability of a film to record a particular hue accurately, such as the color of bluebells in a woodland scene. But the facility can also be applied in a much more dramatic way, so that the reds in a scene are changed to blue or green, for example.

There are a number of different routes to achieving the same, or a very similar, effect, and the one you choose can often be dictated by the nature of the subject and the way in which you want to make changes. I used two methods to make the changes to the images on these pages, Image Select/Color Range and Image/Adjust-Replace Color.

altering the reflection

With an image of normal tone and contrast I used Image Select/Color Range and used the eyedropper to select the reds in the image. Using the slider, I adjusted the Fuzziness until most of the red elements in the image were selected but the remainder of the scene was excluded. I then inverted the selection and, using Image/Adjust-Replace Color, made the background more blue. After re-inverting the selection, I used Quick Mask and the Eraser tool to exclude the boat itself from the selection. With Image Adjust/Hue and Saturation it was a simple matter to alter the color of the reflection alone to green.

Boat reflection

I photographed the original scene using a long-focus lens on a 35mm camera loaded with Fuji Velvia. I also used a polarizing filter to strengthen the reflection. Altering the color of the reflection to create the image shown here produced a rather odd and more striking effect.

TECHNICAL NOTE

Although Replace Color and Color Range work in the same way, the latter is rather more flexible, as areas of the selection can be removed in this mode. Once the selection is made, it can be used to alter density and contrast as well as color, and can also be saved for future use if needed.

soft-lit image

ORIGINAL IMAGE The lighting for this photograph of Bryce Canyon in Utah was very soft since it was in a shaded area. Consequently, the transparency had little contrast or color saturation and lacked impact. I was not happy with the effect created by increasing these factors, as the result was still rather monochromatic.

VARYING THE COLORS I decided to create more color variation by using Image/Select-Replace Color, sampling each hue in the scene and systematically changing both its hue and saturation until I achieved this effect. Although this image bears little resemblance to the original scene in terms of its color content, it retained the essence of this astonishing landmark but with more impact and interest than my original transparency.

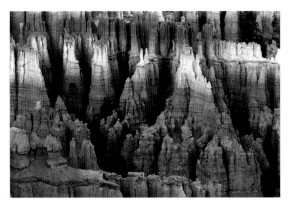

(ABOVE) **Original image**
I used a 35mm camera with a long-focus lens and Fuji Velvia film to shoot this detail of Bryce Canyon.
(BELOW) **Bryce Canyon**
Altering the colors in a selective way gave the photograph a more interesting quality and added impact to the image.

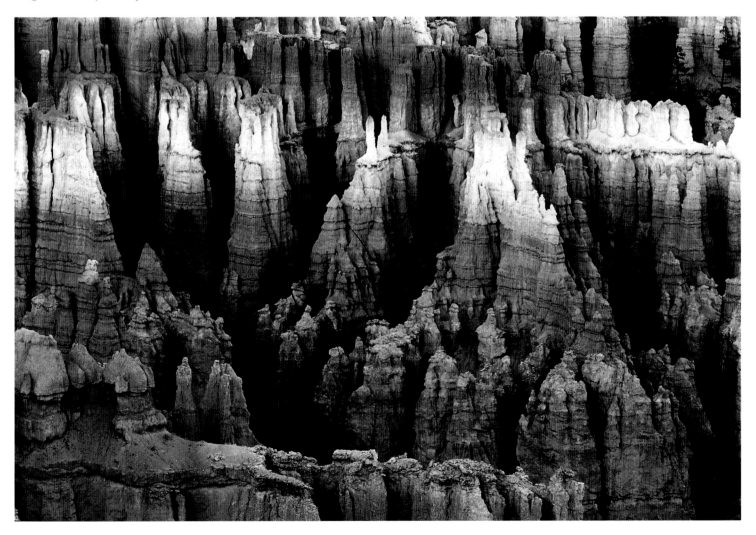

Substituting Skies

One of the techniques sometimes employed by black-and-white printers is to use a sky from another negative to enhance a potentially good photograph that is let down by a lack of tone or interest in this area. It is a difficult procedure, as the two negatives have to be registered carefully on the same piece of printing paper and the unwanted area of each masked during the exposure in a way that creates a good join. I have done it many times, and only once or twice have produced a result that I felt was completely undetectable. But the digital process makes this technique much more manageable and controllable, and also provides a means of doing it in a way that looks completely natural.

replacing a hazy sky

It was a very hazy, almost overcast day when I took this photograph in Maine, and consequently there was little contrast in the scene and the sky was almost white. The resulting transparency was flat and lacked good color saturation — this was easily overcome by adjusting the Levels, but my attempts to improve the sky were unsuccessful. I keep a number of photographs of skies on file for such occasions, and this one, shot at dusk, had a dark, rather bluish quality that I thought would contrast well with the red

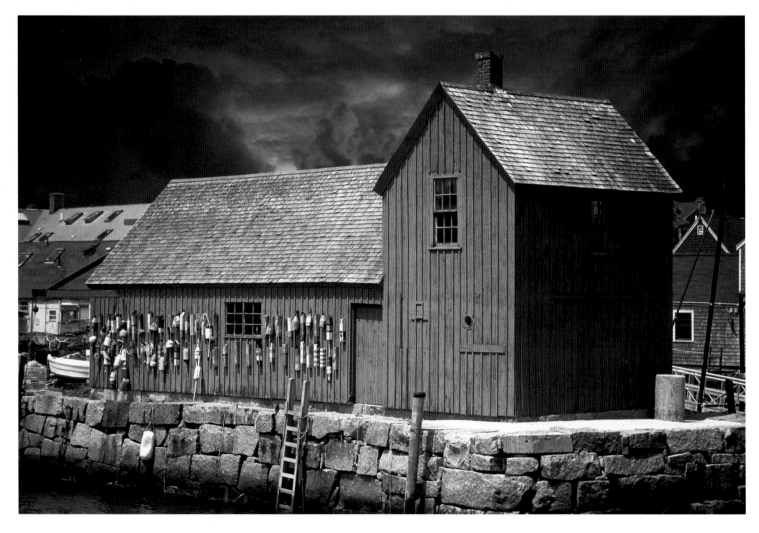

building. I selected the sky area of the dock photograph, using the Magic Wand tool, then inverted the selection, adding a small amount of feathering – just two or three pixels – and copied and pasted it onto the image of the sky. I then used Edit/Transform to alter the size of the sky image until it fitted neatly below the dock image, and used Levels to make it tone in convincingly before flattening the image.

(OPPOSITE) **Maine dock**
The original transparency was photographed on Fuji Velvia using a 35mm camera with a long-focus lens. Increasing the color saturation, and adding a dramatic sky, transformed a rather flat and bland image to that shown opposite.

copying and pasting

I saw this rather splendid field of lavender in the Drôme region of France, but was disappointed by the almost featureless, hazy sky, and framed my pictures to exclude as much of it as I could. I had photographed a quite dramatic sky in Devon, England, a few months previously, and thought that the deep blue and striking cloud formation might well sit happily

with the lavender field. It was a simple matter to select the sky area of the lavender picture using the Magic Wand. I then inverted the selection and applied a small amount of feathering before copying it and pasting it onto the sky. All that remained was to use Edit/Transform-Scale to adjust the two images to give the best fit, and I then tweaked the color, density and contrast of each to achieve a natural-looking match before flattening the image.

(ABOVE) **Lavender sky**
This image was produced by combining two transparencies shot on a 35mm camera, one taken in France and one in England.

bland weather

This strange rock formation was photographed last year in a place called Kodachrome Basin in Utah. During my spell in Utah I was "blessed" with beautiful, sunny weather and almost perfect blue skies, but this can easily lead to rather bland and picture-postcardy photographs.

SMOKY SKY This weird sky was taken in the south of France during a forest fire and the cloud is, in fact, smoke. I photographed it many years ago, long before I had any interest in digital imaging, as I thought it was so unusual that it might be useful for something, sometime.

(ABOVE) **Rock pinnacle**
A mid-range zoom lens fitted to a 35mm camera was used for this shot, with Fuji Velvia and a polarizing filter to intensify the color of the sky.
(OPPOSITE) **Sky pinnacle**
Substituting the sky has overcome the bland quality of a plain blue sky to create a more dramatic image with greater impact.

ADDING IMPACT When I first placed the rock shape against the smoky sky I was struck by how balanced the two images seemed, both in terms of color quality and composition, and the substitution of this sky added considerable drama and impact to the picture. I re-sized the image of the sky to fit the rock image, as the latter was on 35mm and the former on medium format. I then selected the blue sky of the rock image using Select/Color Range, inverted the selection and added a very small amount of feathering before copying it and pasting it onto the smoky sky. As this was a landscape-format shot, I added extra canvas to the base of the image in order to accommodate the rock shot.

(ABOVE) **Smoky sky**
I photographed this section of sky using a medium-format camera, a long-focus lens and Fuji Velvia film.

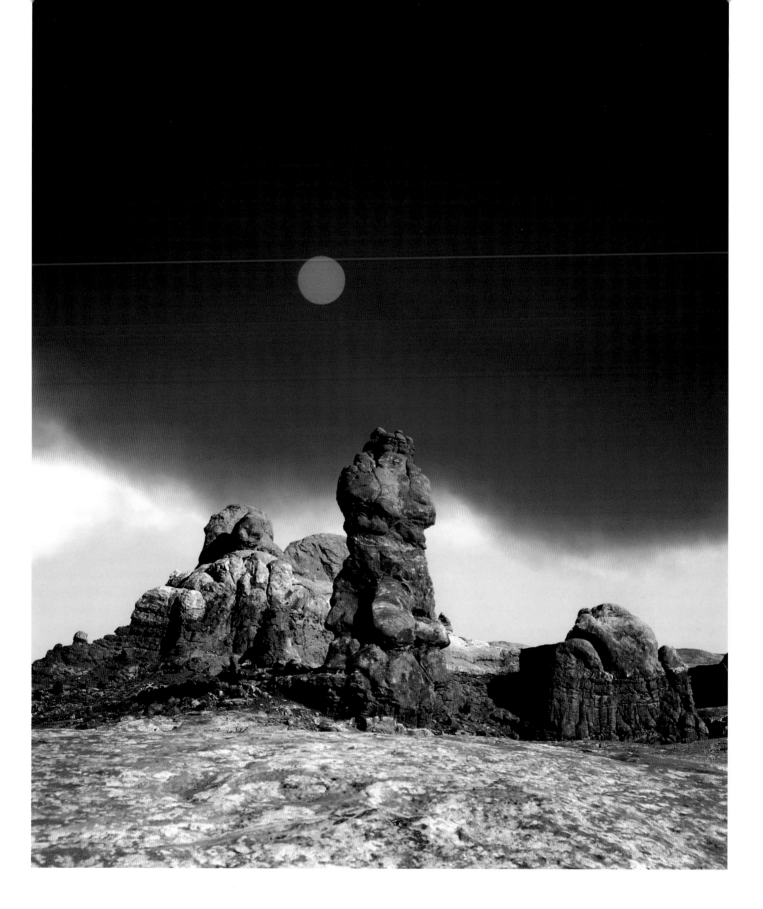

Mirror Images

I imagine that most darkroom workers have, at some time or another, tried making a mirror image by printing one half of an image onto one side of the paper, reversing it in the negative carrier and then printing it again on the other side so that the two images make a seamless join. It's a lot of fun, but very tricky to do in a way that doesn't show. An image-editing program such as Photoshop makes this a very simple operation and provides the facility to make an undetectable join.

making the image central

ORIGINAL IMAGE I photographed Stonehenge, England, late one winter afternoon when there were not many people around, and there was a soft but quite dramatic light from a rather cloudy sky. The first stage of this image was to replace the flat, feature-less sky with one that was more interesting. I chose this one because, although it had some cloud shape and pleasing tones, it was quite low key and reflected the mood of the stones.

ADDING EXTRA CANVAS It was only after I had done this that I noticed the potential of the photograph to make an effective mirror image. I cropped the image in half, choosing a point in the center where I thought the join would be easiest to make and would look most convincing. With the new half image I added extra canvas to the side where I wanted to place the reversed image, making this exactly double its current width, i.e. if the image were 2153 pixels wide, I added the same amount of extra canvas, giving me a new image width of 4306 pixels. I then selected the canvas area using the Magic Wand tool and inverted the selection in order to copy the stones image. I then re-inverted the selection and used Edit/Paste Into to place the stones image into the empty half. I then only needed to go into Edit/ Transform-Flip Horizontal to turn the second image round for a perfect join.

Stonehenge
The stones were photographed on a medium-format camera using a long-focus lens; the Spanish sky behind was shot with the same camera using a wide-angle lens. The film used throughout was Fuji Velvia. I used the mirror technique so as to give the image a more eye-catching and ambiguous quality.

refining details

ORIGINAL IMAGE Joining the same two halves of a person's face is an amusing thing to do, and it can be done either to produce a rather grotesque variation of the subject's appearance or to create a more flattering look. No one's face is exactly the same each side – we all do have a best side – and in this case, with a full-face portrait, I decided to select this side of the face in order to make a perfectly symmetrical portrait.

DIGITAL DENTISTRY I used the method described for the Stonehenge picture and cropped the image at a point between the model's front teeth. However, when joined, the nose seemed too wide, so I recropped at a point slightly to one side of the nose's center to make a thinner and more flattering feature. This, however, resulted in losing the join between the front teeth, making one extremely wide tooth. But I simply went back to the original image, copied just the join and pasted this onto the wide tooth to restore its original appearance.

Woman's face

Heavily diffused studio flash was used to light this portrait taken using a medium-format camera and a long-focus lens with Kodak Ektachrome 64 film. The mirror effect employed did not alter the image dramatically, although the new-found symmetry of the model's face does add a slightly curious quality.

Colorizing Black and White

There are a number of ways in which color can be added to a black-and-white photograph. One of these, which can produce a very pleasing single-toned effect, is to use the Duotone setting in Image/Mode. By selecting two ink colors you can create a wide range of color tone effects without converting the image to RGB. However, when you want to introduce two or more quite different colors it is necessary to convert the image from Grayscale to RGB, which increases the file size three times.

working from dark to light

I photographed this scene in the Forest of Compiègne in Northern France; I was using Ilford XP2 black-and-white film. After scanning and converting the image to RGB, I went to Image/Adjust-Posterize and selected a level of 6. Using Select/Color Range, I chose the darkest of these levels, black in fact. I then chose a very dark blue from the Color Picker for my background color and filled the selection with this. I deselected and reselected the next lightest level, choosing a lighter shade of blue to fill it, and repeated this process for all of the levels, choosing a progressively lighter shade of blue. For the lightest level – white – I selected a very pale yellow as my background color and filled it with this.

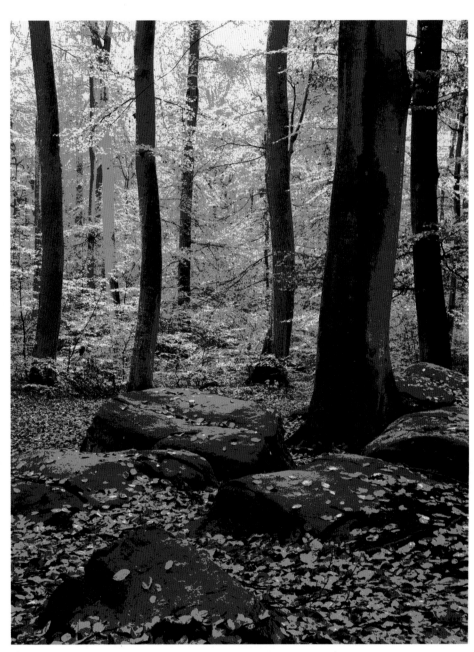

Blue trees
I used a medium-format camera fitted with a long-focus lens set to a small aperture to obtain a good depth of field here; the film was Ilford XP2. I used Posterization to add a range of subtle colors to the black-and-white image.

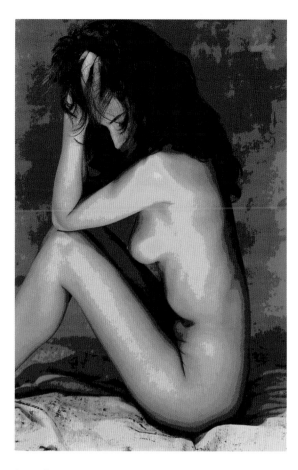

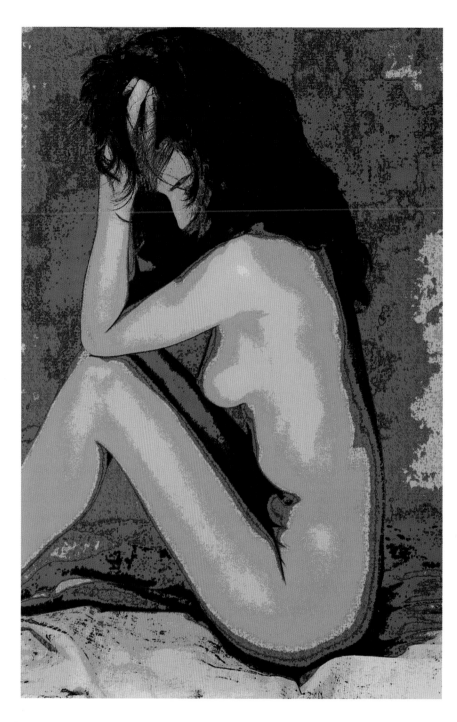

(ABOVE)

Fine-tuning colors

This image was produced in the same way as the forest scene, but I used Image/Adjust-Replace Color to fine-tune the colors I had selected to fill the levels. This has the advantage of your being able to see the changes as you make them, using Hue, Saturation and Lightness, and being able to judge the way in which the new color balances with the existing hues in the image.

(RIGHT)

Reducing saturation

I used the method described for the other nude in order to create this more colorful variation, modifying it overall with a final reduction of color saturation using Image/Adjust-Hue and Saturation.

lith-printing effects

Monochrome photographers have taken to the technique of lith printing in a big way in recent times. It can undoubtedly produce some very pleasing results with its ability to record both contrasty shadow tones and soft mid-tones and highlights, and at the same time, to create a variety of image colors. Both the attraction and drawback of the process is its unpredictability, and the near-impossibility of producing two identical prints. While not in any way being a substitute for the lith process, the computer can be used to emulate some of its characteristics and produce results that are, in their own way, just as pleasing

working from color

ORIGINAL IMAGE The image below was a medium-format color transparency exposed on Fuji Velvia. Although I was quite pleased with the photograph as a color image, it lacked contrast and bite due to the very soft lighting of the overcast, snowy day. My first thought was simply to increase the contrast

Snow trees

A medium-format camera loaded with Fuji Velvia film was used for the original image. It was fitted with a long-focus lens set to a small aperture with a long exposure to ensure enough depth of field. I used tonal and color manipulations so as to create a lith-type quality.

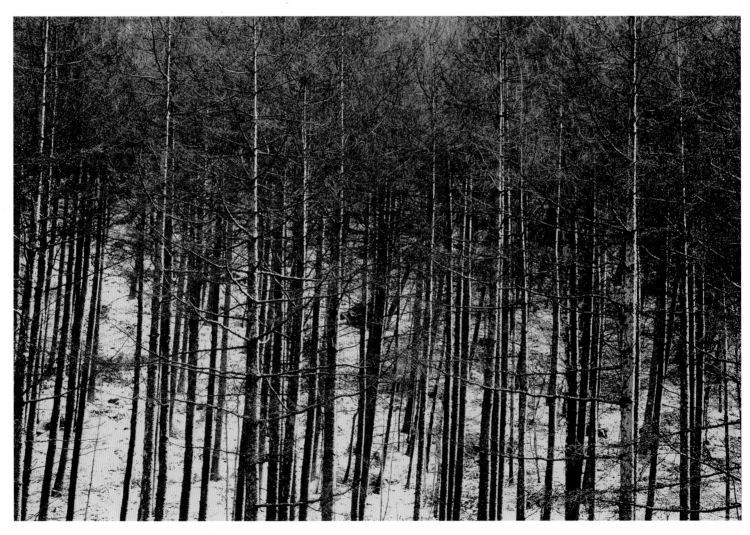

and perhaps the color saturation, but on reflection I thought that it might work better as a lith-style monochrome image.

REMOVING THE COLORS After scanning I then desaturated the image using Image/Adjust. I made a duplicate layer and then, using Image Adjust/Levels, made it very soft, with weak shadows and degraded highlights. Going back to the background layer, I made another adjustment layer and, using Levels, made this very hard, with dense black shadow tones and bleached-out highlights. With an additional adjustment layer set to Color Balance, I added blue and cyan to the shadows.

ADDING SEPIA I opened a new Adjustment Layer for the copy layer and, with it set to

Color Balance, gave the mid-tones a sepia tint. I used Layer/Options-Blend, experimenting with the way in which the two layers interacted and going back to both Levels and Color Balance, adjusting each to fine-tune the effect. Darken mode produced the most pleasing effect.

ADDING BACKGROUND After flattening the image, I used Image Select/Color Range to select the highlight tones and filled this area with the background color set to a pinkish hue. I tried this several times, altering the fill color slightly and adjusting its opacity until I arrived at a tint that blended well with the existing image color and also had the look of a lith print.

Golden avenue
This scene, shot on a misty day, was photographed on a 35mm camera with a mid-range zoom lens and Ilford XP1 black-and-white negative film. I used Layers and Curves to create a split-toned effect, and to enhance the mood of the scene.

hand-painting effects

The only means available to the early photographers of adding more than one color to a black-and-white photograph was to apply paint by hand. Some of the images produced in this way were very beautiful indeed, and this technique is still practiced by some contemporary photographers. But it does require a reasonable amount of skill with a brush and, like many other traditional techniques, there's no going back – a spoiled print must be discarded.

A digitized image can be colored in a similar way, and although some skill is needed, there is the big advantage that the image can be enlarged to an enormous degree, making it possible to apply color to even tiny areas very accurately. In addition, errors can be rectified easily, quickly and as many times as necessary.

using the airbrush

To color the above image I used the Airbrush tool set to a low pressure. This tool applies the foreground color selected by sampling the Color Picker. For most of the areas I had the Airbrush set to Soft Light Blend mode, which produces an effect comparable to using transparent watercolors or dyes when

Chemise

I used Kodak Recording film – a fast, grainy black-and-white negative film – in a 35mm camera fitted with a mid-range zoom lens for this portrait, lit by window light. Soft, patchy color, applied with an Airbrush tool to a black-and-white image, has created a subtle and rather old-fashioned color image.

using a brush in the traditional way. When I made a mistake – which was frequently, as I'm not very skilled with even a digital brush – I simply used the Sponge tool to desaturate the image back to gray. I used pastel colors, often mixing several hues together to give a deliberately patchy effect. I restricted the one really strong color to the model's lips in order to create a focus of attention.

using the marquee

I cheated quite a lot with the photograph below and only used the Airbrush tool to tidy up. I first gave the image an overall brownish tint by using Image/Adjust-Hue and Saturation and checking the Colorize box. By adjusting the sliders I created a wide range of hues. Next, using the Marquee tool, I selected each of the windows in turn, then opened a new layer. I applied the selection to the new, empty layer and filled the spaces with the background color of blue I'd selected in the Color Picker. I did the same with the doorway, altering the fill color. I then set the blend mode to Color. I selected the café lettering using the Magic Wand tool, then filled this with an orangey red. I made final adjustments to the colors using Image/Adjust-Replace Color before flattening the image.

French café
This ancient façade was photographed using a long-focus lens fitted to a 35mm camera; the film was Fuji Velvia. The image was desaturated before I began the coloring process.

Creating Special Effects

While the introduction of effects filters for cameras led to a wave of pretty hideous distortions of what were frequently poor pictures to begin with, the unrestrained use of digital effects and filters can easily outdo them on all counts. It's probably this that has tended to give digital photography a bad name in some quarters. But when used in conjunction with other tools, and when their effects can be modified by use of multiple layers and blending modes, there are some interesting possibilities for using effects filters.

While I take my photography quite seriously most of the time, I'm by no means averse to having a little fun with it occasionally, and some of the effects that imaging software allows you to create fall into this category. But techniques discovered and learned in this context will not be wasted since they can often give rise to many other possibilities and can help you to develop ideas and establish a personal style.

French doorway
A number of the techniques described in this chapter have been used to give this image a quality that would not be possible by conventional photographic means.

Blending Layers

Most photographers using film who have the urge to produce images that are more than a straightforward record of a scene or subject have probably, at some time or other, experimented with techniques such as double exposures and slide sandwiches. These techniques can produce some striking effects and provide a means of creating more abstract and ambiguous images, as well as providing an opportunity to express ideas that cannot be fulfilled in a single exposure. Image-editing software like Photoshop not only makes techniques like these much easier and more controllable to carry out, but can also extend them in ways that are hard to visualize until you become aware of the possibilities. One of the most important and flexible aspects of creating images in this way is the ability to blend two or more separate layers in a huge variety of ways.

TECHNICAL NOTE

As with many image-editing facilities, there is almost always more than one way of creating the same or a very similar effect, or of refining the one you have achieved. When working with Blend modes or Layer Options, for instance, you can also try varying the hue, saturation, contrast, brightness and opacity of the individual layers to give further control over the final effect.

Golden waterfall
I used a medium-format camera with a wide-angle lens to record this image, and set a small aperture with a slow shutter speed to produce some blurring in the water; the film was Ilford XP2. I then used Layers to alter the tonal quality of the image and Duotone to add color.

working on two layers

This image began as a black-and-white negative. After scanning and making basic Levels adjustments, I made a duplicate layer. I increased both the brightness and the contrast of the top layer and then made the bottom layer much softer and slightly darker. This effect was created by setting the Blend mode to Difference. I then went back to both layers and made small changes to both their density and contrast to fine-tune the effect. Lastly I flattened the image and, using Image/ Adjust, inverted it. The color was introduced by changing from Grayscale to Duotone in Image/Mode and selecting the ink colors until I arrived at this golden hue.

adding color

I photographed this frosted leaf in color but, although I have a liking for quite monochromatic color photographs, I've always felt that this picture was just a little too much so.

PUSHING THE COLOR I first tried increasing the color saturation to see if I could accentuate some of the latent colors within the image, which would provide some contrast to the overall bluish hue, but this had little effect.

CREATING WARMTH I tried another tack by making a duplicate layer and, using the Curves, altered the colors of this top layer to introduce some warmer hues. With the Blend mode set to Color, I went into Layer Options and adjusted the blend between the two layers to give this effect. After flattening the image, I used Image/Adjust-Hue and Saturation to fine-tune the colors.

(ABOVE) **Frosted leaf** *I used the Layers and Blend modes, and Curves, in order to reveal more color within this image.*
(LEFT) **Original image** *I used a long-focus lens fitted with an extension tube on a medium-format camera for this close up; it was exposed on Fuji Velvia.*

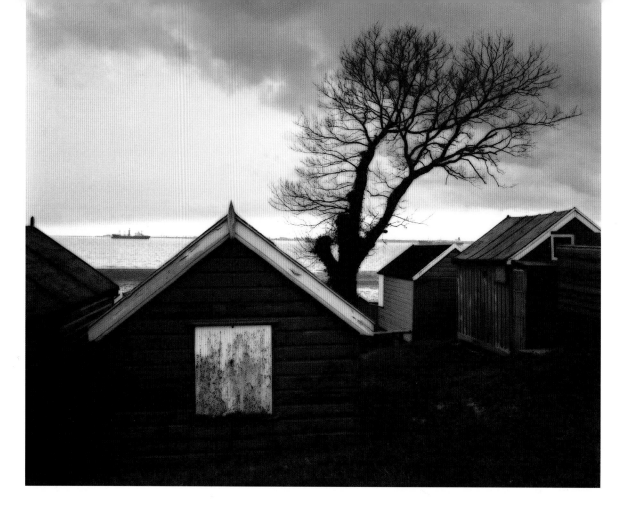

Huts and tree

I used a medium-format camera with a long-focus lens and Ilford XP1 negative film for the original shot. Layers were used to create this diffused, two-color effect.

using diffusion

A technique often used by traditional black-and-white workers is to introduce a degree of diffusion into an image; a popular device is to place a piece of nylon stocking over the enlarger lens during part of the exposure, which has the effect of making the dark tones bleed a little into the adjacent lighter areas. Using diffusion for only part of the exposure enables you to control the degree of the diffusion, but with a digitized image and the use of layers you can control not only the degree of diffusion but also how it reacts. You can make light tones bleed into dark areas and vice versa, and you can also add color to the individual layers, giving the diffusion a further range of effects.

introducing diffusion

I decided to introduce a diffused quality into this picture of beach huts, as the darker details of both the hut and the tree were strongly silhouetted against the lighter tones of the sky.

DUPLICATING LAYERS After scanning, and adjusting contrast and brightness, I converted the image from Grayscale to RGB. I next made a duplicate layer and applied a degree of Gaussian Blur to this layer using Filter/Blur, and set the Blend Mode to darken before flattening the image. I next made a duplicate layer from this image.

WORKING FROM THE BASE With the top layer made invisible, I went back to the base layer and, using Image/Adjust-Color Balance, introduced a reddish-brown tint to the shadow tones of the image. Going back to the top layer, I selected the darker tone of the image with Select/Color Range and deleted them, allowing the dark tones of the base image to show through. Using Image/Adjust-Color Balance I made the highlight tones of the top layer a more yellow shade of brown to provide some contrast to the richer darker tones.

multicolored effect

I was not concerned with introducing diffusion into this black-and-white photograph of a derelict bus shelter picture, but I did want to introduce a multicolored effect, and blending layers was a good way of doing this.

MIXING THE LAYERS After converting from Grayscale to RGB, I made a duplicate layer and, using the Color Balance control, gave the image a bluish tint. Making this layer invisible, I then went to the base layer and used the same method to give it a reddish-brown hue. With the Blend mode set to Normal, I used Layer Options to produce this mix of the two layers before flattening the image.

FINE-TUNING THE COLORS To introduce the third color, I made a new layer and filled it with a pale yellow and set the Blend mode to Multiply. I fine-tuned this color by using the Hue and Saturation control, and made a final adjustment to the overall quality of the image using Layer Options.

Bus shelter
This photograph was taken using a medium-format camera with a long-focus lens and Ilford XP1 black-and-white negative film. I used Layers to add color to the image.

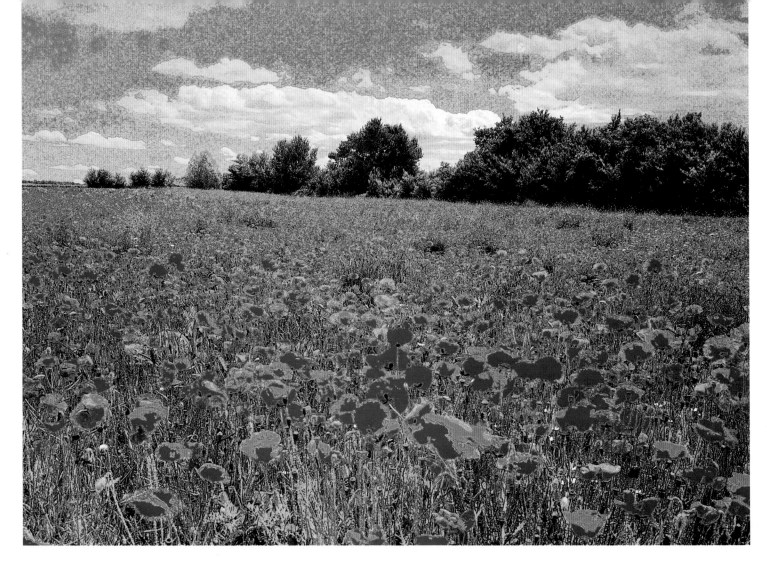

filters and options

Blending layers can be another effective way of using filter effects, and it also provides a very controllable way of creating images with a more painterly or graphic quality. The Layer Options control can be a powerful tool when dealing with multiple layers, but there's no rule of thumb when using it in this way. Altering the Highlight and Shadow sliders for both the active layer and the one below provides an almost limitless way of blending them. By holding down the Alt key you can separate each of the sliders and adjust them in both directions, giving many further options.

using layer options

ORIGINAL IMAGE I took this photograph one summer in the Languedoc region of France, but although it was quite pleasing it had a bit too much of the pretty postcard quality about it to make it very interesting, and it seemed to be a good candidate for some digital manipulation.

MAKING A LINE IMAGE I adopted a two-stage approach, the first making a duplicate layer and rendering the base layer as a line image using the Threshold control. I set the Blend mode of the top layer to Screen and then copied it again and set the new top layer to Normal, adjusting the blend in Layer Options. I went back to the base layer and adjusted the brightness and contrast of the Threshold image before flattening the image. A final adjustment was to give the sky a slightly more saturated and darker tone in order to create a better balance with the foreground.

LIGHTENING THE EDGES I next made a duplicate layer of this image and applied the Find Edges filter to it with the Blend mode set to Lighten.

(OPPOSITE) **Poppy field**
For the original shot I used a medium-format camera with a wide-angle lens and Fuji Velvia. A polarizing filter was also used to intensify the colors. I went on to use a variety of effects to make the image look less photographic.

I made a final adjustment to the image quality by tweaking the blend between the two layers using Layer Options.

partial solarization

I used a long exposure to obtain the smoky effect on the water when taking this shot, but felt that although the water was quite striking, the rest of the image was rather ordinary. I wondered if I could add some interest by introducing a partially solarized effect, which I had achieved before by blending a negative layer with the positive.

I first made a duplicate layer and desaturated and inverted it, giving me a black-and-white negative, and then set the Blend mode to Difference. After flattening the image I adjusted the contrast and brightness of the image using the Curves control, and slightly reduced the color saturation.

(RIGHT) **Waterfall**
The original picture was taken on a medium-format camera using a long-focus lens and Fuji Velvia film. I used a slow shutter speed to render the moving water as a soft, smoke-like blur. I created a pseudo-solarized effect to give the image a more unusual and dramatic quality.

Threshold Effects

When working in the darkroom, one of the techniques I liked to use with some subjects was the use of very high contrast to give a line effect, sometimes using lith film to render a subject purely in tones of pure white and black. With the right type of subject and negative, this could produce very pleasing images, not unlike an Indian ink sketch or a scraperboard drawing.

In Image/Adjust a control called Threshold achieves the same effect. The slider enables you to set the point at which the image divides; all tones lighter than this point will be pure white, and those darker will be black. In this way you can control the amount of detail and texture retained in the image together with the balance between the amounts of black and white.

With the right subject, the Threshold control can produce some interesting and pleasing images, and there are a variety of ways in which it can be modified and combined with other techniques to create a wide variety of effects.

warhol-style image

I produced the image shown above, using the mirror technique described on page 78, from a color negative. The original photograph had a fairly plain background of golden-colored grass that was out of focus. I had always been struck by the portraits produced by Andy Warhol in which the image is reduced to black and white, with a colored face shown against a black background, and this gave me the idea for zebra image.

(OPPOSITE) **Reducing color**

For this effect I first made a duplicate layer and applied the Threshold control, adjusting the slider until only the very darkest tones remained and most of the image was white. I next selected the white areas using Select/Color Range, and deleted them. This allowed the color image below to show through, and on this I reduced the contrast and increased the brightness so that only a hint of color remained.

CHANGING THE BACKGROUND Because the animal was photographed against a very light background, the Threshold control rendered it as pure white. The nature of the zebra's black-and-white markings meant that I could simply invert the image without altering its appearance very much, but this gave me a black background. Because I did not want the background in this picture to be black, I selected it using Select/Color Range and filled it with purple. I next inverted the selection and then filled the light tones with a pale blue, using Image/Adjust-Replace Color to fine-tune the two colors until I liked the balance between them.

(ABOVE) **Zebra**
The original was a color negative shot on Fuji Superia 400 color negative film using a 35mm camera with a long-focus lens. I've used the techniques described on this page to give the image a graphic, poster-like quality.

building up combinations

The Threshold control played an important role in the two images on these pages, but I combined it with other effects. I find that it is usually a combination of image-editing effects that produces the most interesting results, but only when they are applied to the right subject – this pertains particularly to effects filters. I tend to use them mainly to enhance or exaggerate a quality that already exists within the photograph, instead of simply imposing the effect on it – rather in the way that a sunset filter used on the camera looks obvious and unattractive when applied to a flatly lit scene with a gray sky, but can look both convincing and pleasing when applied to a sunset that simply lacks color.

George

I used a medium-format camera with a long-focus lens and Fuji Astia film for this studio-lit portrait. I have manipulated the image in order to give it a hard and gritty quality.

adding skin texture

I wanted to give this portrait of my friend George a rather harsh and gritty quality, which I thought would accentuate his rugged features and uncompromising expression.

GOING TO MONOCHROME I made two copy layers of the image and made them both invisible. With the base layer, I used Threshold to render it as pure black and white, adjusting the slider so the maximum amount of skin texture was revealed. I next went to the middle layer and set the Blend mode to Darken.

COLORING AND BRIGHTENING I applied the Noise filter to the top layer, choosing a fairly coarse setting, and set the Blend mode to Overlay. With the top two layers linked, I used Image/Adjust-Hue and Saturation to make the skin color much more subtle, and after flattening the image, used the Curves control to make the image brighter.

setting the base layer

This black-and-white photograph, taken in a Paris park, seemed to have the right qualities for this type of approach – a good tonal range with a lot of detail, and no large areas of very dark or light tones.

BLENDING THE LAYERS After scanning and adjusting the brightness and contrast to give me maximum detail, I converted the image to RGB. I next made a duplicate layer and applied the Find Edges filter under Filter/Stylize. Using Layer Options, I adjusted the two-way sliders until I achieved the desired blend between the two. Then using Curves, I altered the neutral base layer to give a hint of green and blue before flattening the image.

STRENGTHENING THE BLACK I liked the quality of this image but wanted the black lines to be stronger. So the next

Paris park

A black-and-white negative shot on Ilford XP2, and using a 35mm camera with a mid-range zoom, was the basis for this image. I used manipulations in order to give the image a little more bite and to add a subtle color.

stage was to make a duplicate layer from this image and then make it invisible, in order to see the base layer. Going back to this I went to Image/Adjust-Threshold and, by moving the slider, made the image appear with only the most important details and outlines rendered in black, with the remainder of the image as pure white.

FINAL TOUCHES Returning to the top layer, I set the Blend mode to normal and, using Layer Options, adjusted the two-way sliders to create this balance between the line and tone layers before finally flattening the image.

Find Edges Effects

I consider the Find Edges filter to be one of the most useful in the effects department. Used in its raw state, however, although its sketch-like quality is initially interesting, it can rapidly become somewhat boring and repetitive, with all images ending up rather the same. But when combined with other effects and used on separate layers, where it can be blended and modified, it can produce some very interesting qualities and sometimes unusual and unexpected effects.

detailed image

This filter can produce more striking effects with images that have a great deal of clearly defined details, as opposed to those with large areas of plain tones or colors. This shot of a helter skelter slide, taken at the English seaside resort of Cromer, is a good example of this type of photograph, and the accompanying images show just some of the effects that can be created with the Find Edges filter. Many more variations of this image are possible by altering the Blend modes, adjusting Layer Options, changing the order of the layers, and altering the brightness, contrast and hue of the individual layers.

DUPLICATE LAYERS Using the normal but saturated image, which I scanned and adjusted from a color negative, I made two duplicate layers. I applied the Find Edges filter to the first layer and then inverted it.

UNINVERTED FILTER This image shows the uninverted version of this filter, which I applied to the top layer.

(RIGHT) **Original image**
I used Fuji Reala color negative film for this shot, taken on a 35mm camera with a mid-range zoom lens.
(FAR RIGHT)
Helter skelter
This shows the effect of applying the Find Edges filter and adjusting the density and contrast of the resulting image.

(ABOVE) **Helter skelter**
Combining the original scan with two duplicate layers to which the Find Edges filter has been applied, with one inverted, produced this softer effect.
(RIGHT) *This image shows a duplicate layer of the original scan with the Find Edges filter applied and then inverted, with the Blend mode set to Luminosity.*

SATURATION AND SOFT LIGHT I produced this effect by setting the first layer to the Saturation Blend mode and the top layer to Soft Light.

APPLYING FIND EDGES The final image was produced by making a duplicate layer, applying Find Edges, inverting it and setting the Blend mode to Luminosity.

old-fashioned effect

I wanted to give this photograph of a farm museum, taken in the Bresse region of France, a sketchy, old-fashioned, hand-painted quality in order to overcome the rather over-renovated look of the building, but in a way that still managed to retain its essential photographic and color quality.

REDUCING THE OPACITY After the basic levels adjustments I made a duplicate layer, which I inverted using Image/Adjust-Invert, and then desaturated. I set the Blend mode to Darken and I reduced the opacity by about 30 percent before flattening the image.

WORKING INTO MONOCHROME I next increased the contrast and brightness before making a duplicate layer and applying the Find Edges filter using Filter/Stylize. I then desaturated this and increased the brightness and contrast of this layer to give a purely black-and-white image. I next selected the white tones using Select/Color Range and deleted these, leaving only the black lines.

USING FILTERS I then made a duplicate layer from the background image, placing it on top, and applied a small amount of Fresco Filter, using Filter/Artistic with the Blend mode set to Soft Light. I then reduced the opacity of this layer until I got the effect I liked. I adjusted the contrast and density of the image after flattening it and, as a final touch, used the Lasso tool to select the roof area in order to reduce the color saturation and brightness so that it matched the rest of the image.

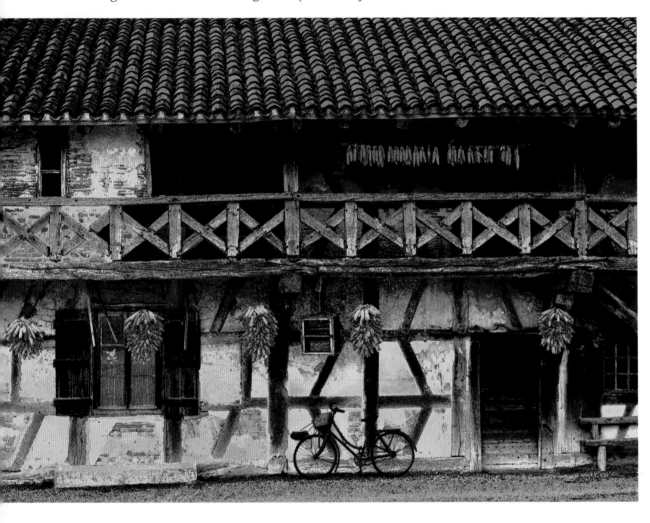

French farmhouse
For this, the original transparency was shot with a medium-format camera with a long-focus lens and Fuji Velvia film. I applied a number of techniques to this image to create a less photographic quality and to enhance the slightly old-fashioned atmosphere of the scene.

changing the color

I first made a duplicate layer and set the Blend mode to Exclusion before flattening the image. I made a duplicate layer of this image and applied the Find Edges filter, setting the Blend mode to Overlay. I adjusted the brightness and contrast using the Curves control after flattening the image, and then selected the background area using the Magic Wand tool. With this selection in place, I desaturated the background and made it slightly darker. I then inverted the selection and used the Curves control to make a final adjustment to the brightness and contrast of the bloom.

Sunflower

I used a 35mm camera with a long-focus lens and an extension tube for this close-up; the film was Fuji Velvia. This manipulation has altered its color and tonal quality, and given it an element of surprise.

Filter Effects

There are numerous techniques and filters that can be used to modify a digital image, often beyond recognition. Some of these are contained within an image-editing program, but there are many that can be bought as plug-ins. Although it might seem at first that there are thousands of possible effects, many of these are simply variations on the same theme and, it has to be said, are often so crude and unattractive that it is difficult to visualize how they might be used to produce a pleasing image. But sometimes they can be applied in ways that emphasize a particular quality in an image, or that can be modified by blending layers in order to create quite interesting variations on an image.

using poster/edges

The three variations of this still life of cans were produced by the application of various filters. The first was the result of using Poster/Edges, found in Filter/Artistic.

WRAPPING THE IMAGE For the second image I applied the Plastic Wrap filter, also in Artistic, then selected the cans with the Pen tool, converting the path into a selection. I then inverted the selection so as to make the background darker using Levels.

ACCENTED EDGES The third variation was produced by first making a duplicate layer and applying Accented Edges in Filter/Brush Strokes with the Blend mode set to Difference. I fine-tuned the effect by adjusting Layer Options and Levels.

(ABOVE) **Cans**
The Poster/Edges filter was used to produce this effect.
(LEFT) **Original image**
This still life was photographed using a medium-format camera with a long-focus lens and studio flash. The film used was Fuji Astia.

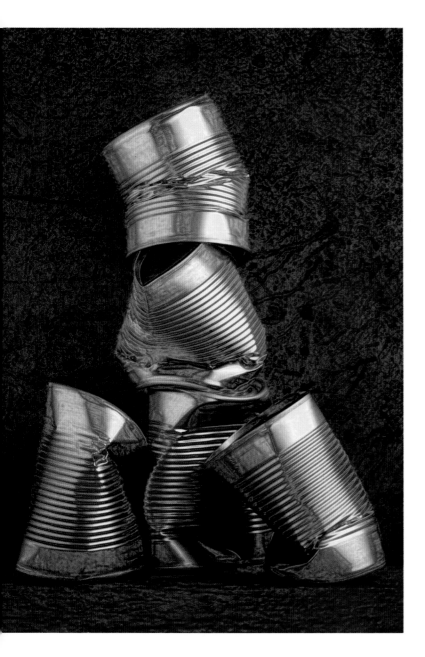

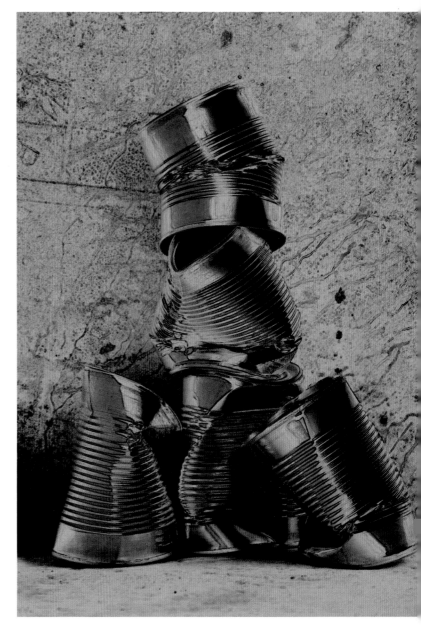

Cans

(ABOVE LEFT) *I used the Plastic Wrap filter to create this effect, and also made the background darker.*

(ABOVE RIGHT) *I used a duplicate layer for this image, applied the Accented Edges filter to the top layer, and then adjusted the Blend mode.*

Noise and Bitmap Effects

The effect of using enlarged film grain on an image has always been popular with photographers, especially those working in black and white. The use of very fast film, aggressive development and high degrees of enlargement can produce such pronounced grain that the image begins to be quite broken up, and this can often add to the mood of an image and make it more ambiguous or abstract. Adding the effect of grain to a digitized image is a simple matter, but the straightforward use of a filter often looks less interesting than the real thing, and it is worth exploring ways of modifying this effect or looking for other means of breaking up the image.

Male torso
This studio shot was taken using a medium-format camera with a long-focus lens, and was exposed on Kodak Ektachrome 64 film using a diffused flash. I manipulated the image in order to produce a grainy, broken effect and a more abstract quality.

TECHNICAL NOTE

The size of the Bitmap pattern in relation to the image is governed by the number of pixels in the pattern image, and the size and output in pixels of the main image. You will probably need to vary these factors until you get a large enough bitmap pattern to be recognizable, but that does not break up the main image too much.

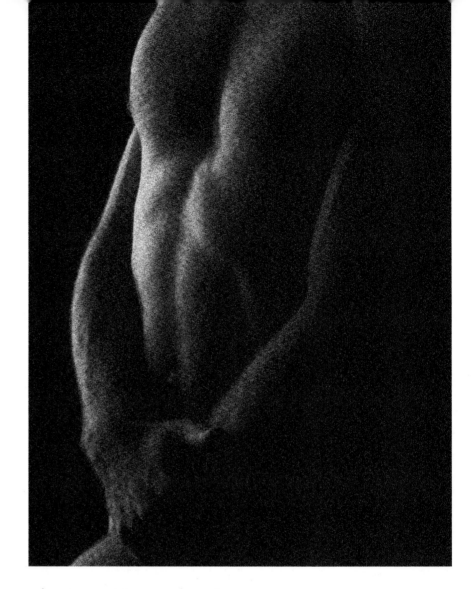

abstracting the image

I photographed this male torso in the studio using moody lighting and color transparency film, but wanted to make it look more abstract and atmospheric.

GRAINY EFFECT My first step was to apply the Noise filter in Filter/Noise-Add Noise, choosing the monochrome setting. This created a very grainy effect, but looked a bit too raw for my liking. I softened the effect slightly by applying Despeckle found in the same menu, but it was still not quite right.

SOFTENING I made a duplicate layer and applied Median, which softens the image, again in the same menu, and set the Blend mode to Luminosity, giving a final adjustment of the effect in Layer Options. After flattening the image I adjusted the color, density and contrast using Curves.

using the bitmap mode

For this image I used the Bitmap mode found in Image/Mode. It can only be applied to a Grayscale image, so I converted my color image from RGB. I selected just the animal's head, then copied it and pasted it onto a new file, reducing the image size to 100 pixels wide. I then went to Select/All and Edit/Define Pattern. Returning to the main image, I went to Bitmap and selected Custom Pattern with an output of 600 pixels per inch and clicked OK.

ADDING COLOR Because I wanted to add some color, I first had to convert the image from Bitmap to Grayscale, then to RGB – you can't go directly from RGB to Bitmap or vice versa. I next used Select/Color Range to isolate the white areas of the image and filled them with a pale turquoise.

Zebra
I photographed this animal in Kenya using a 35mm camera with a long-focus lens and Fuji Superia 400 color negative film. This effect was created by using the tightly framed animal's head as the Bitmap element from which the image was formed.

Making Patterns

As far as having fun with digital image control is concerned, I find it hard to beat making patterns – in fact, I'm going to launch myself into a new career as a fabric designer. It's a pretty simple process, however you go about it, but success lies in choosing the base image before you begin the pattern-making process.

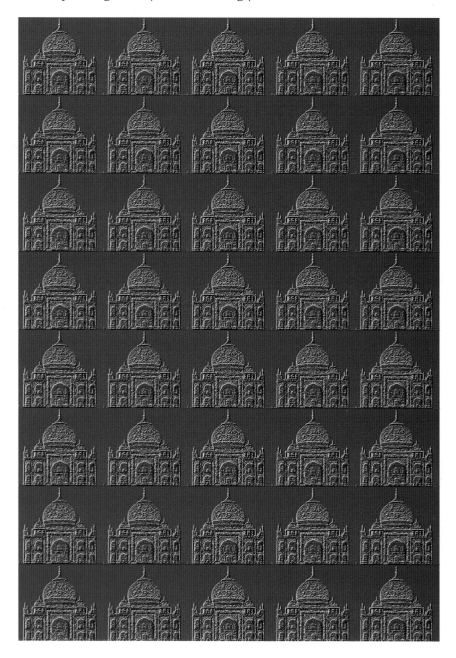

using texturizer

This image makes use of the Texturizer to be found in Filter/Texture. First I cropped a section of a photograph of the Taj Mahal to give me this tightly framed image. I converted it to Grayscale and reduced the image size to 500 pixels wide before saving the file onto the desktop. Next, I opened a new file, 2000 by 3000 pixels, with the blue background color I had selected, and went to Filter/Texture-Texturizer. I clicked on Load Texture, scrolling the menu until I came to my Taj Mahal file. Double-clicking this brought the image into the Texturizer panel, where I was able to control its size and the degree of relief using the sliders before clicking OK. This gave me a white image on a blue background, so I selected just the whites using Select/Color Range and filled this selection with a gold tint to give the image a little more contrast and impact.

Taj Mahal pattern
The transparency used to create this pattern was shot on a 35mm camera using a long-focus lens and Fuji Velvia film. The pattern was created by using a photograph of the Taj Mahal as the image element in the Texturizer filter.

TECHNICAL NOTE

The effect of the pattern depends upon using an image with a bold outline and well-defined detail when viewed in black and white. You also need to experiment with the pattern's scale and degree of relief in the dialogue box, perhaps trying a few variations before you arrive at the most pleasing effect.

creating a composite image

A close-up of a leaf was the starting point for this pattern. I first made the color and tonal range of the image more dramatic by partially solarizing it in the way described on page 113. I then cropped a small section of it and saved it as a new file, making a mirror image in the way described on page 78. I repeated this process a number of times, adding extra canvas as I copied and pasted to build up the composite you see here. My final image was rather tall and narrow, so to give it more pleasing proportions, I went to Image/Size and unchecked the Constrain Proportion box and resized it to give me a 2:3 ratio of top to sides.

Leaf pattern

The original close-up shot used to produce this pattern was taken on a 35mm camera using a macro lens and Fuji Velvia. I repeated the mirror process a number of times to create the effect shown here.

TECHNICAL NOTE

As you repeat each mirror process, it is a good idea to reduce the image size, since the file size can quickly escalate to an unmanageable number of megabytes as you build up the pattern.

Original image
I used a medium-format camera with a long-focus lens and an extension tube to shoot the close-up image on which these patterns were based.

Plane-tree bark
A mirrored image combined with the Wave filter produced this effect.

duplicating patterns

A close-up photograph of the bark of a plane tree was the starting point for these images. I cropped out a section that I felt I could develop into a pattern, and made a mirror image in the way described on page 78. I next altered the colors using Curves, and then mirrored it again to create the first image shown here.

USING THE WAVE FILTER I then applied the Wave filter, found in Filter/Distort. The next step was to make a duplicate layer of this image and apply the Wave filter again, but in a different form.

MOVING THROUGH THE LAYERS I then experimented with altering the Blend mode, simply progressing through just a few of the countless permutations that are possible by changing the relationship between the layers in various ways – the shape of the wave pattern, the Blend mode, making adjustments with Layer Options, inverting the top image, inverting the base image, adding a new layer and filling it with color, and so on. It became almost obsessive, the digital imager's equivalent of doodling.

TECHNICAL NOTE

The effects on this page are the result of the individual qualities existing in the base image, and even slight changes to its contrast, density and color saturation would produce a very different result. Another image would produce an entirely different effect. Consider this "technique" as merely an idea with which you can experiment, rather than as a precise formula for creating a particular kind of image.

Plane-tree bark
(ABOVE LEFT) *A second layer with the Wave filter applied at an opposing angle produced this effect.*
(BELOW LEFT) *Altering the Blend Mode has changed both the pattern and also the colors.*

(ABOVE) *Another variation of the Blend mode and an adjustment in Layer Options produced the final effect of the same basic image.*

Making Joiners

Photographers have always explored the possibilities of joining up a number of separate photographs to create a new, composite image. David Hockney made this process famous, and took it to impressive lengths a couple of decades ago with his "joiners"; digital photographers now have the prospect of 360-degree panoramas, shot as a sequence of individual photographs and joined together seamlessly with special software. It can be fun. Here are two quite simple ways of creating a joiner effect, using a single image to begin with.

making segments

This is a very adaptable way of creating a joiner. Having opened your selected image, open a new file somewhat larger and place them side by side on the desktop. You can use the background color you intend to finish up with, or use white and fill it accordingly later. For this image I wanted to have irregular segments so I used the straight-line Lasso tool to draw a selection of the desired shape onto the new file, and went to Edit/Paste Into. I then repeated this process until I had enough segments to create a more or less recognizable version of the original image. You don't need to be too careful about the position of these images – they are easy to move because they are individual masked layers. To move the segment itself you must click on the mask, and to move the image within it click on the image.

Broken bottle
I used a medium-format camera with a long-focus lens for this studio-lit still life; it was exposed on Fuji Provia. Copying and pasting sections of the original image into a new file produced the segmented effect shown above.

moving layers

I also used layers for this picture of a shopping arcade in Brussels, Belgium, but simply drew selections, using the Marquee tool, around areas of the image, copied them and then moved them slightly to a different position. Using Edit/Transform you can alter the shape, angle and scale of these copied selections to add a further disturbance to the image. And, of course, if you wish you can also alter the color balance, contrast and density of some of the sections.

Brussels arcade

The original transparency was shot on a 35mm camera using a wide-angle lens and Kodak Ektachrome 100 SW. Copying and moving sections of the original image created a disrupted, but still readable, version of the photograph.

TECHNICAL NOTE

You can introduce a further element to images like this, built up on separate layers, by adding an effect. Layer/Effects offers a variety of choices, from Drop Shadows to Bevel and Inner Glow. I added a fairly subtle Drop Shadow to some of the segments of the arcade image.

Abstracting the Image

There are occasions when a sharp, clear image is undesirable: when attempting to create a particular mood, for instance, or an atmospheric effect. One of the more appealing qualities possessed by a great many of the very early images created by the Victorian photographers was their lack of clarity and definition. This often gave them a slightly mysterious and unworldly quality, though it was probably due more to the shortcomings of the equipment and materials available to them than any creative intent.

Modern cameras and films are capable of breathtaking clarity and definition, and to overcome this a number of popular techniques are often used as needed, such as soft-focus attachments, shallow focus, shadowy lighting, movement, blur and so on. When used in-camera, however, they can be a bit hit-and-miss, and they are not reversible. The ability to experiment with methods of introducing an element of abstraction into an image, in a way that allows you to change your mind or modify it, is one of digital imaging's great strengths.

depersonalizing an image

The nude is a subject where a degree of abstraction is often desirable, both in order to create mood and to depersonalize the image. I shot this picture in the studio, using lighting that created quite large areas of shadow for this reason, as well as positioning the model and framing the image to give it a more abstract quality. But I wanted to take this image further still from being a straightforward record of the subject.

MAKING LAYERS My first step was to make three duplicate layers of the image. I deactivated the top two, and with the first I set the Opacity to 35 percent and Blend mode to Luminosity and very slightly increased its size, using Edit/Transform-Scale. I then nudged it by a few pixels using

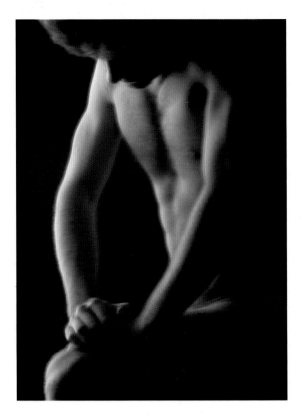

Male nude
(LEFT) *I used multiple layers here to create an effect of movement and blur.*
(RIGHT) *I used a new layer filled with a color to change the mood of the image.*

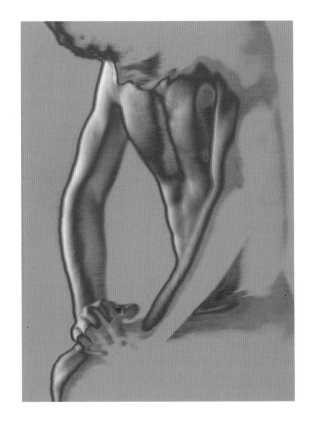

the Move tool and the cursor arrows. With the second layer active I desaturated it, decreased its size slightly in the same way, and set the Blend mode to Overlay with the Opacity at 35 percent. I applied a degree of Motion blur to the third layer, using Filter/Blur, and set the Blend Mode to Lighten with Opacity at 100 percent.

SOLARIZING THE DARK TONES Continuing with this image after flattening, I made a duplicate layer and used Select/Color Range to select the darkest tones of this image, which I filled with a gold color to create a solarized effect. I made fine adjustments by altering the Hue and Saturation of the fill color.

Male nude

(BELOW) *A change of the Blend mode and adjustments to Hue and Saturation have created this variation.* (RIGHT) *Inverting the image and using a duplicate layer to alter the tonal range and color quality produced this final effect.*

CHANGING THE FILL COLOR The third effect was made by beginning with the flattened version of the first image and opening a new layer, which I filled with the same gold tint, setting the Blend mode to Exclusion at 100 percent Opacity and again making fine adjustments by altering the Hue and Saturation of the fill color before flattening the image.

INVERTED IMAGE The fourth image is simply an inversion of the previous image, which I modified by making a duplicate layer and selecting the darker tones, using Select/Color Range, increasing their density and setting the Blend mode to Luminosity.

FINAL TOUCHES I made final adjustments to the Color Balance after flattening the image.

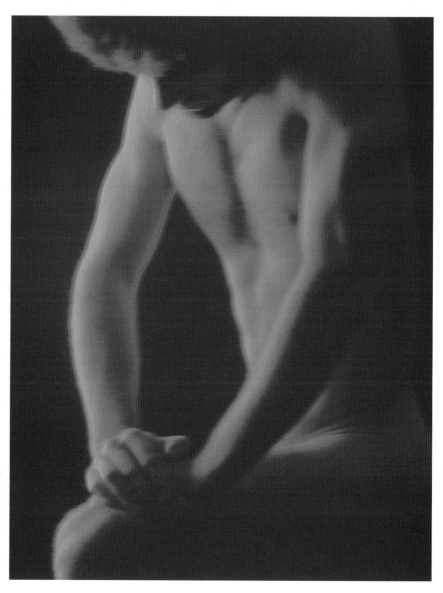

multiple exposures

The camera technique of making multiple exposures on the same frame of film and moving the image slightly between each can, with the right subject, be very interesting. The snag is that it is not possible to see the effect until after the film is processed, and consequently there is virtually no control, other than by intelligent guesswork based on previous experience.

A further drawback is that, when shooting on transparency film, the light tones of one exposure only records when juxtaposed against the darker tones of another. The opposite effect can of course be obtained by sandwiching several overexposed transparencies together slightly out of register. With an image that consists of pixels, not only can you combine these effects into a single image, but you can also view and control them as you progress.

working with six layers

I began by making six duplicate layers of the image below. Beginning with the first layer, I then altered, very slightly, the position of each layer, offsetting the image both laterally and vertically by just a pixel or two, using the cursor control to nudge it. I progressed through all the layers in this way, also altering the Blend mode and adjusting the Layer Options of each one. In addition I desaturated two of the layers and inverted one of them while also increasing the color saturation of the base layer. On finally flattening the image I made adjustments to the color, brightness and contrast, using the Curves control.

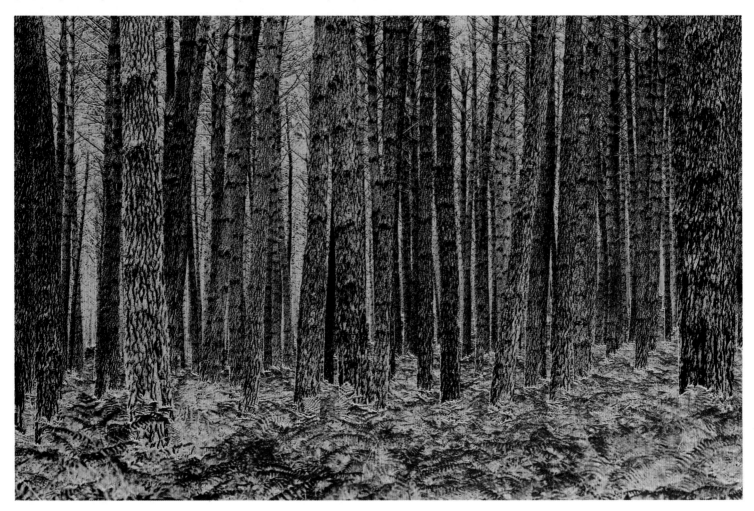

TECHNICAL NOTE

I could probably repeat this process with a very similar image and not get the same effect, but it is a simple matter to see how the effect of each layer contributes to the image, or otherwise, as you go along. When completed, it is a good idea to work through the layers one at a time, switching them off to make sure that they are actually helping the overall effect.

blurring the image

This effect was quite simple to achieve. I made two duplicate layers and applied the Motion Blur filter in Filter/Blur to the first, setting it to an angle of 45 percent, and the Blend mode set to Multiply and Opacity at 100 percent. I applied the Motion Blur filter to the second layer at the opposing angle of 315 percent, with the Blend mode set to Screen and Opacity at 100 percent. I adjusted the effect using Layer Options and, after flattening the image, adjusted the density, contrast and color saturation.

(OPPOSITE) **Forest trees**
I used a 35mm camera with a long-focus lens and Fuji Velvia film to make the original transparency. The use of multiple layers has been used here to emulate the effect of a sequence of exposures that were made on the same frame of film in the camera.

(RIGHT) **Tree row**
This scene, photographed in Normandy, was shot on a 35mm camera using a wide-angle shift lens and Fuji Velvia film. I used a polarizing filter to enhance the sky and foliage. The effect of movement blur has been used to give the image a more graphic and abstract quality.

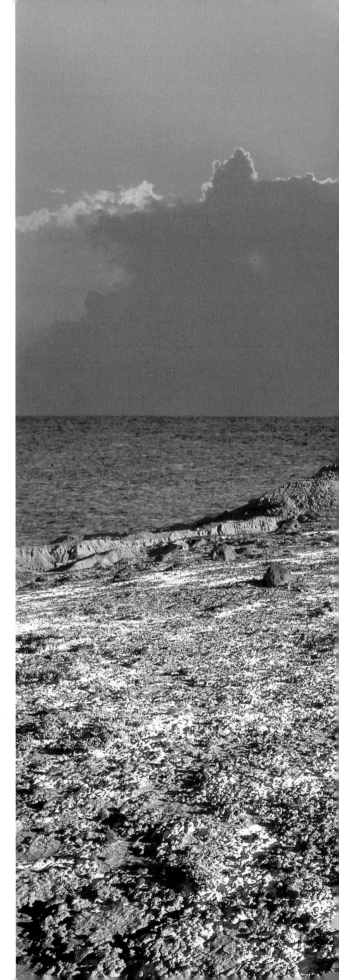

Creating Composite Images

Building a composite image from a number of different elements has fascinated many photographers since the very early days. The traditional methods in this area include cutting out and pasting prints together, montaging negatives in the darkroom, and making multiple exposures in the camera. But the numerous ways in which images can be combined when dealing with pixels are simply astonishing, allowing a photographer to express his or her ideas almost without limit.

With digital control it is possible to create images that have more to do with painting than they do with traditional photography, and it's no coincidence that some of the finest exponents of this genre also have a background in fine art or graphic design. This is perhaps the aspect of digital imaging that provides the greatest freedom for personal expression and offers the most intruiging challenge to the imagination, as well as revealing a new way to recognize the possibilities when taking photographs.

Tree and sunset
Three transparencies were combined to produce this composite, with one, the foreground, turned into a mirror image.

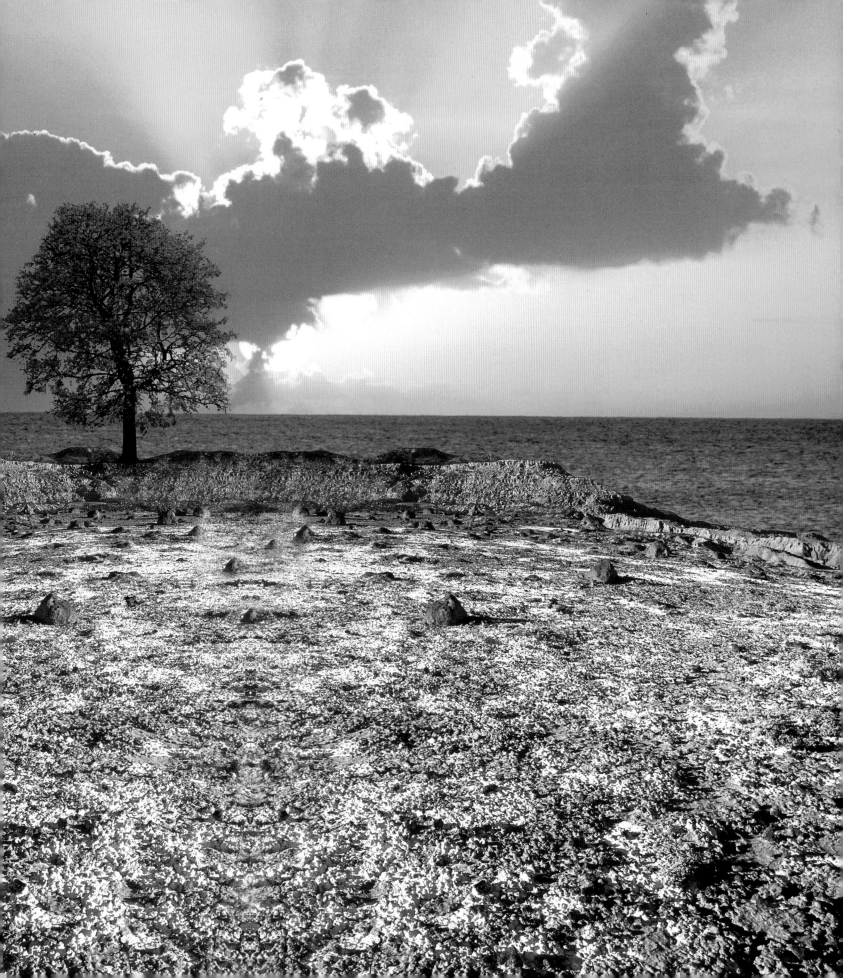

Creating a Composite Image

In silver-based photography, combining two or more images is a quite complex process with a very limited degree of control, and once done it cannot be altered. But when working with pixels, the individual images can be kept together in separate layers and continually manipulated until the desired effect is achieved before blending into a single layer.

Graffiti

35MM CAMERA; MID-RANGE ZOOM LENS; KODACHROME 64

Flag

35MM CAMERA; LONG-FOCUS LENS; KODAK EKTACHROME 64

Car

35MM CAMERA; MID-RANGE ZOOM LENS; FUJI VELVIA

american graffiti

THE ELEMENTS The idea for this image stemmed from a photograph taken some years ago of a graffiti-covered wall in San Francisco. I had photographed the car in Rajasthan – it was part of a Maharaja's collection – and the flag was in front of a building in Los Angeles.

THE FIRST STEP After scanning all three transparencies, I made basic color and levels adjustments to each of them. I increased the color saturation of the wall image and established this as the background layer.

PLACING THE SUBSEQUENT IMAGES I used the Pen tool to create a path around the flag's outline, turning it into a selection and copying it onto a new layer above the wall. I then selected and copied the whole of the tightly framed car image onto a third layer. With both these images I used Edit/Transform-Scale to adjust their relative sizes and position on the background layer until I felt there was a nicely balanced composition.

TIDYING THE JOINS I next created a mask on the car layer and, using the Airbrush, masked out the areas that I did not want to show through, in a way that allowed some fading around its edge. I then adjusted the Opacity and Blend modes to create the required amount of see-through, also tweaking the contrast and density using Image Adjust/Levels. I used the same methods to control the effect of the flag and also increase the color saturation using Image Adjust/Hue and Saturation.

A FINAL TOUCH Before flattening the image I applied a small amount of Fresco filtration to the graffiti using Filter/Artistic.

American graffiti
This composite was created from existing slides but it can be more satisfying to visualize an image, making sketches perhaps, and then photograph the individual components especially for this purpose. In this way you can ensure that the outlines of objects and details are clearly defined to make selecting them easier.

Joining Elements

Perhaps the easiest way to create a composite image is to join two or more elements along a naturally dividing line, such as a horizon, especially if it is clearly defined. The mirror images described on page 78 are an extension of this technique, but the same method can also be used to produce a more natural-looking result.

pollution

THE ELEMENTS I began with the idea of using this dramatic sky as a means of illustrating the idea of pollution. It is, in fact, a vast cloud of smoke created by a forest fire in the south of France. The sea was a shot taken on the Spanish Costa del Sol and was quite neutral in color. The mountain is a section from a landscape photograph taken in the Capitol Reef National Park in Utah.

ADDING CANVAS After adjusting the density and contrast of the sky, I added enough extra canvas below it to accommodate the land and sea images. Going to the landscape, I selected the sky area using the Magic Wand tool; this was easy, as it was a dense, clear blue and created a strong contrast with the color of the rock.

(LEFT) **Smoke**

MEDIUM-FORMAT CAMERA; LONG-FOCUS LENS; FUJI VELVIA

(BELOW LEFT) **Sea**

35MM CAMERA; MID-RANGE ZOOM LENS ; FUJI REALA

(BELOW) **Mountain**

35MM CAMERA; MID-RANGE ZOOM LENS; FUJI VELVIA; POLARIZING FILTER

PASTING THE SELECTION Next I inverted the selection, copied the land mass and then pasted it onto the sky. I repeated this a couple of times, feathering and contracting the selection very slightly until there was no visible edge to the join. I find this is often preferable to the De-fringe facility found in Layer/Matting, as this sometimes creates artifacts.

INTRODUCING THE COLORS I used the Magic Wand to select the sky area of the sea image, and then I inverted this in order to copy just the sea, which I then pasted onto the sky and mountain combination. With this layer open, I used Image/Adjust-Curves to introduce the rather strange colors, which I thought suggested pollution quite effectively. I went back to each layer, making slight adjustments to the levels and color until I was happy with the balance between them, and then flattened the image.

FINAL TOUCHES I finally softened the line between the land and sea by selecting just the join, using the Marquee tool, and applied a small amount of Gaussian Blur.

Pollution
It was possible to produce an almost naturalistic image from three separate transparencies because they had an element of compatibility.

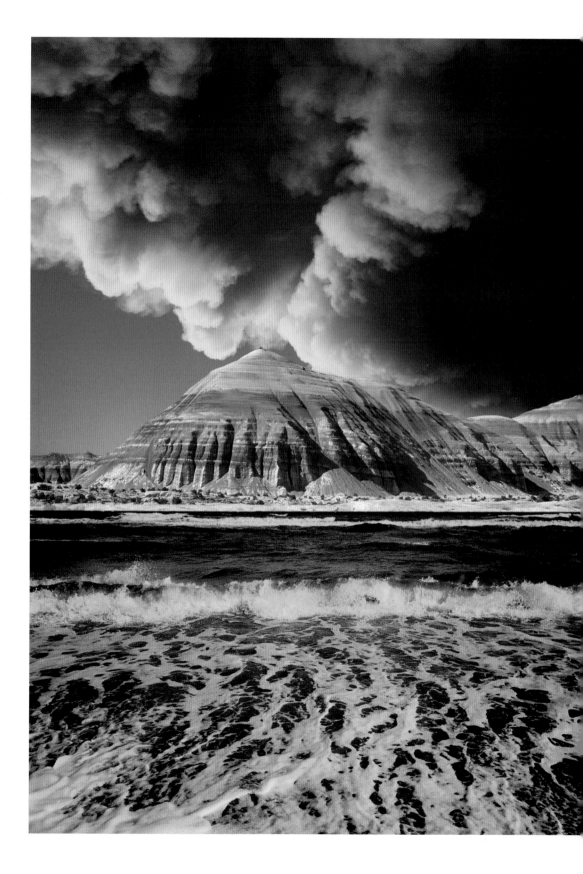

Creating Composite Images • **121**

Creating a Logical Flow

There are many examples of images of this type where there is no real connection between the individual components. Indeed, some set out to achieve their impact by their sheer incongruity, using a sort of shock treatment, where an image of a fish might be combined with an architectural detail and a flower, for instance. I may be a bit old-fashioned, but I prefer my images to have a certain logic, where an identifiable idea is expressed. One approach to deciding on the elements for a multiple image is to think of a theme or abstract concept that might be illustrated.

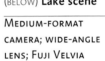

memories

THE ELEMENTS I took this portrait of an elderly lady a couple of years ago, and although it was not deliberately posed in this way, it suggested the theme of this composition. The second element was pretty obvious, as it seemed highly probable that a fair proportion of time spent remembering things, after a certain age is reached, is concerned with childhood. I found this very attractive photograph of a young girl, of about the right period, in an old postcard album at a yard sale. The bonus was that her head angle and the direction of her eyes allowed me to place her in a way that seemed to return the older woman's gaze. I used my flat-bed scanner to capture this image.

FINDING A BACKGROUND The third element was decided upon by the need to have a background. An overall image upon which the subsequent ones can be placed is usually desirable, and needs either to be quite bland and sparing in detail or with suitable gaps or holes into which the other images can be

(ABOVE) **Victorian child**
An old postcard that was scanned on a flat-bed scanner provided this element of the composite.

(BELOW) **Lake scene**

MEDIUM-FORMAT CAMERA; WIDE-ANGLE LENS; FUJI VELVIA

(ABOVE) **Old lady**

35MM CAMERA; LONG-FOCUS LENS; FUJI ASTIA

dropped. This shot of a very still lake, photographed in the Sologne region of France, seemed ideal, as it had just enough interest to make a contribution to the image but had large plain areas that would not complicate it too much. I thought too that the bluish color quality suited the mood of my composition, and the reflection neatly underlined the lady's pensive expression.

PUTTING IT TOGETHER I began with the lake scene and copied and pasted the other two images onto it, adjusting their size and position using Edit/Transform. I set the Blend mode of each to Normal and reduced the opacity to about 70 percent so they would not be too blunt and the slight see-through effect would enhance the somewhat dreamlike quality. I made masks for each of them and painted out areas where I wanted the background to show through more. I used the Printing-in tool to reduce the density of the lake scene where I wanted the upper image to be stronger.

Memories
The still, bluish quality of the background image helped to create the reflective mood of the image.

Seeking Out Objects

As my interest in digital photography has developed, I now make a habit of looking for objects or details that might be useful in the future as an element in a composite image. I find that things with interesting shapes are particularly useful, and if they are clearly defined against a contrasting plain background it is a relatively easy matter to select them.

boulder sunset

THE ELEMENTS I photographed these images on separate occasions, with the thought that they might be useful at some point as elements in a composite image.

FIRST ATTEMPT I established the sunset as the background image and adjusted its density, contrast and color to a level where it seemed compatible with the rock image. This was quite easy to select, as the blue sky was a strong contrast to the stone and I was able to use the Magic Wand tool to obtain a clean outline. I used a small amount of feathering, just two or three pixels, to soften the edge a little before copying it and pasting it onto the sunset image. But the result was too blunt and the two images did not look right together, and I felt that the image needed at least a suggestion of reality. I was prepared to abandon this as a viable composition, but decided to try first a means of softening the overall effect.

USING LAYERS I opened a new layer and placed it between the two images. Using

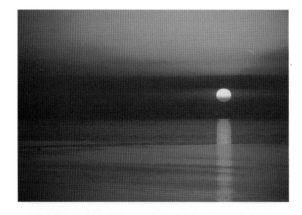

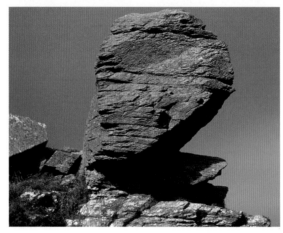

(TOP) **Sunset**

35MM CAMERA; LONG-FOCUS LENS; FUJI VELVIA

(ABOVE) **Boulder**

35MM CAMERA; LONG-FOCUS ZOOM LENS; FUJI VELVIA; POLARIZING FILTER

TECHNICAL NOTE

When making a selection of an object against a plainish background, I often find it easier to make a duplicate layer first and then increase either the brightness, contrast or color saturation until the background creates the strongest contrast with the detail I want, and then make the selection using the most appropriate means. The duplicate layer can then be discarded, leaving the selection in place on the original image.

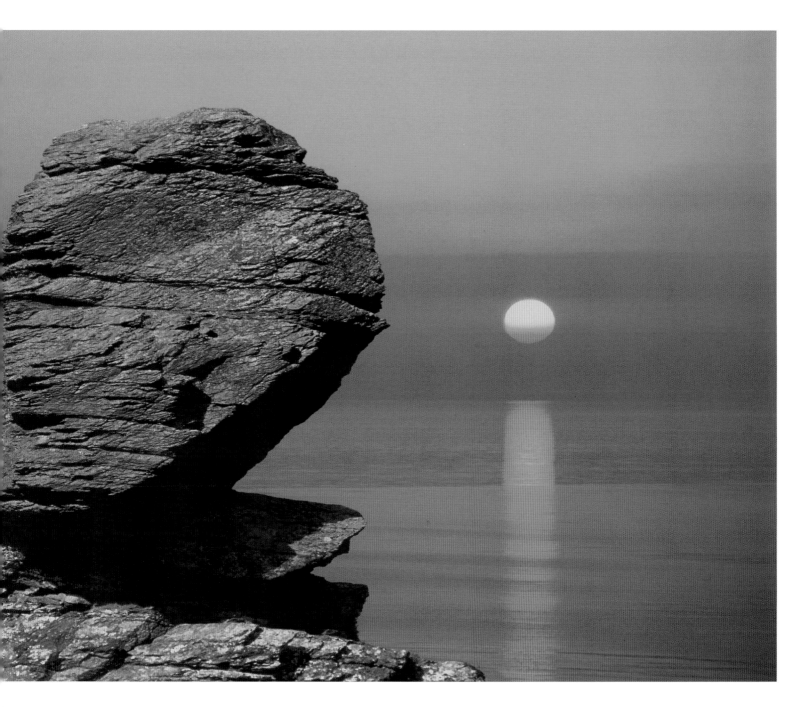

the Linear Graduate tool with the Background to Transparent setting, I filled this layer with a very pale blue so that it became denser toward the top of the image. I then set the Blend mode to Lighten and adjusted the effect, using Layer Options.

This is rather like using a graduated filter on the camera, but placing it behind the foreground details.

FINAL TOUCHES Before flattening the image, I made final adjustments to the color, contrast and density of the two images.

Boulder sunset

The introduction of a third layer, used to create a slightly misty effect, helped to make this image seem a little more realistic.

Developing an Image

Sometimes an image seems to evolve: I have an idea, and when I begin to work on the elements a new direction suggests itself. This is one of the most enjoyable aspects of digital imaging because, unlike traditional darkroom work, it is possible to develop an image to a certain point and then return to it on another occasion and continue where you left off.

painted meadow

THE ELEMENTS There are just two basic elements in this composite image. The background image was photographed near my home in Kent, England, on a very fast color-transparency film that was processed in C41 to give a very grainy negative with slightly odd colors. The second image was photographed in the La Mancha region of Spain, using a long-focus lens to compress the perspective, concentrate the effect of the colorful flowers, and create a very shallow depth of field.

COPYING AND PASTING I first adjusted the levels of the tree photograph to create a quite contrasty image that accentuated the grain. I then made a selection of the flower meadow image using the Rectangular Marquee, copied it and pasted it onto the tree image. I did this a number of times, using slightly different areas of the flowers each time.

REMOVING THE JOINS Using Edit/Transform, I adjusted the size and position of the flower patches until they covered the foreground of

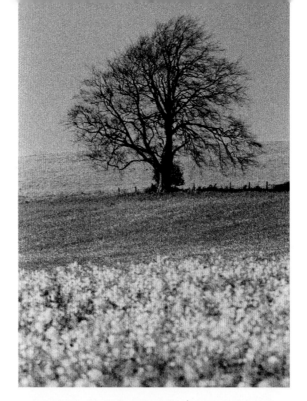

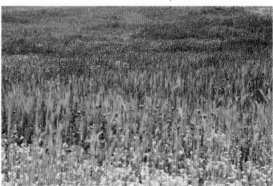

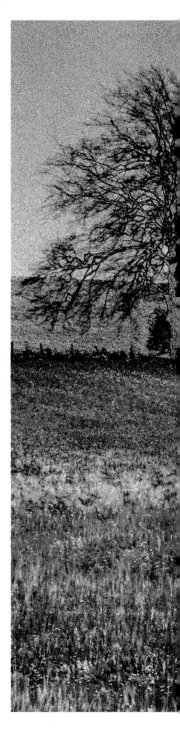

(TOP) **Tree**
Cross-processing a fast color transparency film has produced this grainy image, which was shot on a 35mm camera with a long-focus lens.

(ABOVE) **Flower meadow**

35MM CAMERA; LONG-FOCUS LENS; FUJI VELVIA

the tree picture, and then reduced the opacity to obtain a subtle blend, which I further adjusted by making masks of each of these layers and painting out any noticeable joins.

GETTING A DIGITAL LOOK When I was happy with the overall effect, I flattened the image. I wanted this image to look very digital, and

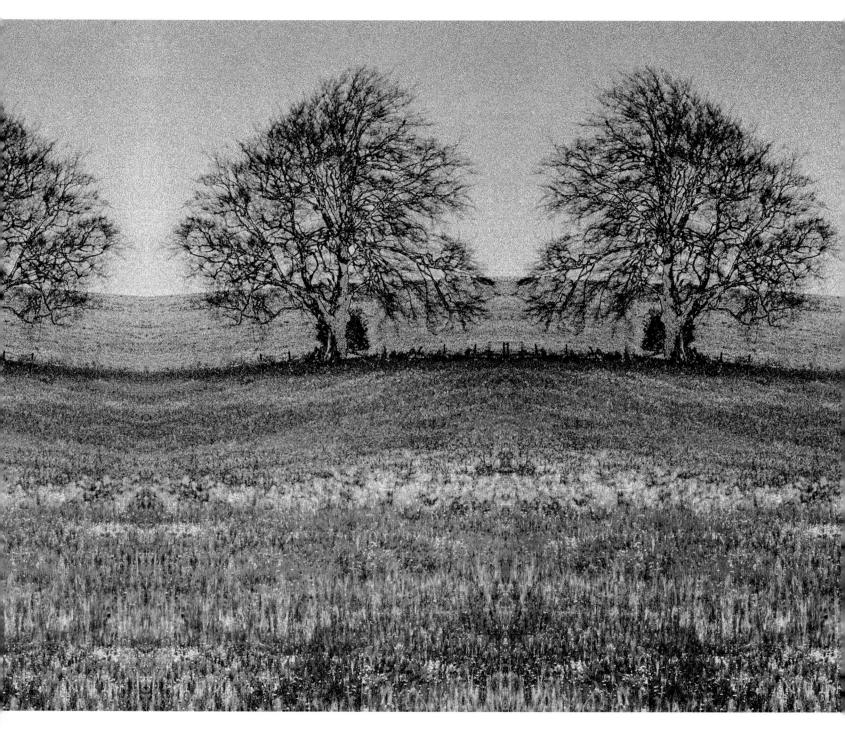

decided to go a few stages further. First, I selected the tree trunk and branches using the Magic Wand, and then applied the Find Edges filter to create this sketch-like effect. **MAKING MIRROR IMAGES** Next, I opened a new file three times the width of the tree and flower image. I then selected the latter and pasted it onto the new file three times, reversing and joining them in the way described in making mirror images on page 78.

Painted meadow
This image combines a number of effects from conventional and digital photography.

Creating Composite Images •

Finding Backgrounds

As well as being on the lookout for objects with interesting shapes that can be used as a point of focus for a composition, I have also made a collection of plainer, blander images that can be used as backgrounds for composite images. Subjects such as skies, water and some textured surfaces can be invaluable in this way.

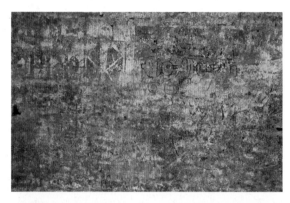

(TOP) **Blue wall**

35MM CAMERA; MID-RANGE ZOOM LENS; FUJI VELVIA

(ABOVE) **Sunflower**

35MM CAMERA; LONG-FOCUS LENS AND EXTENSION RING; FUJI VELVIA

icons

THE ELEMENTS Although I was attracted by the color and texture created by the script on this graffiti-covered wall in Rajasthan, I was aware that on its own, it did not make a completely satisfying image. The statue was photographed in a French village, and I liked the idea of using it in a way that accentuated its religious character but, at the same time, created an ambiguous quality.

PLACING THE FIRST IMAGE I established the wall as the background and then selected the statue, using the Magic Wand to copy and paste it onto the wall. Using Edit/Transform, I adjusted the statue's size and position to create a pleasing balance within the detail of the wall. I set the blend mode to Darken to create a slightly mottled effect, made a mask of this layer and used the Airbrush tool at low pressure to paint out some of the statue's edge and soften the outline.

ADDING ANOTHER IMAGE I placed the sunflower on a layer above the statue, with the Blend mode set to Normal. I used Radial Blur to create this starburst effect, as in its normal state the sunflower was too obvious, and I liked the impression of a halo produced by the blur. I made a mask for this layer and painted out enough of the sunflower's center to allow the statue to show through.

BALANCING THE COMPOSITION The composition was now distinctly lopsided, and needed another element in the top right corner to create a satisfying balance. I remembered a

(ABOVE RIGHT) **Star**

35MM CAMERA; LONG-FOCUS LENS; FUJI VELVIA

(RIGHT) **Statue**

35MM CAMERA; MID-RANGE ZOOM LENS; FUJI VELVIA

curious obelisk I had photographed in France (see pages 50–51), and thought that the golden star-shaped sculpture on top might just do the trick. Having selected and copied it, I placed it in position on a layer immediately above the background and adjusted its size to create a good balance. The effect was rather too blunt and pulled the eye too strongly from the statue, so I reduced the opacity of this layer to about 70 percent to make its presence less intrusive.

TECHNICAL NOTE

When an image has been selected and added to another, the effect can be too bold, even when the selection is feathered. But I find even just a very slight reduction in this layer's opacity can soften the effect without allowing the background to show through noticeably.

Icons
I positioned the individual elements within the borders of this image in order to create a balanced and harmonious composition.

Focus of Interest

When I first began to appreciate the opportunities offered by the digital process, there were a number of situations where something lacking in an image could be easily overcome, such as lack of contrast and color saturation. But there were also occasions when a very photogenic scene simply lacked a suitable focus of interest. How easy, I thought, to simply drop in a suitable object. Not so, I found, if the result was to look at all convincing – I tried placing a small, silhouetted fishing boat into a stunning sunset over the sea, for example, yet no matter how I tried I could never believe it.

track and church

THE ELEMENTS This photograph of a track running through a field of dead sunflowers was shot in France a few years ago. I wondered how much more impact there would be with something at the end of it, so I decided to experiment. The church was quite distant in a fairly bland landscape shot on the Romney Marshes in England – a similar distance, in fact, to where an object would be on the horizon of the track shot.

REPLACING THE SKY I needed extra space at the top of the track shot, as I cropped out most of the weak sky already there. In my sky file I found this photograph, which I felt had a suitable brooding quality; and also, the color could be made to blend with the landscape. I therefore established this image as the background layer and added some extra canvas at the base.

ADDING THE TRACK AND CHURCH Selecting the sky in the landscape shot using the Magic Wand, I inverted it and applied a small amount of feathering before copying the land and pasting it onto the sky background. I next selected the church, using the Pen tool to create a path, which I then converted to a selection. I feathered it slightly and pasted

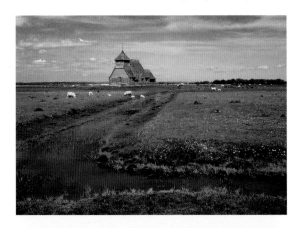

(TOP LEFT) **Church**

35MM CAMERA; MID-RANGE ZOOM LENS; KODAK ELITE

(ABOVE LEFT) **Sky**

35MM CAMERA; LONG-FOCUS LENS; KODAK EKTACHROME 64

(LEFT) **Track**

MEDIUM-FORMAT CAMERA; LONG-FOCUS LENS; FUJI VELVIA

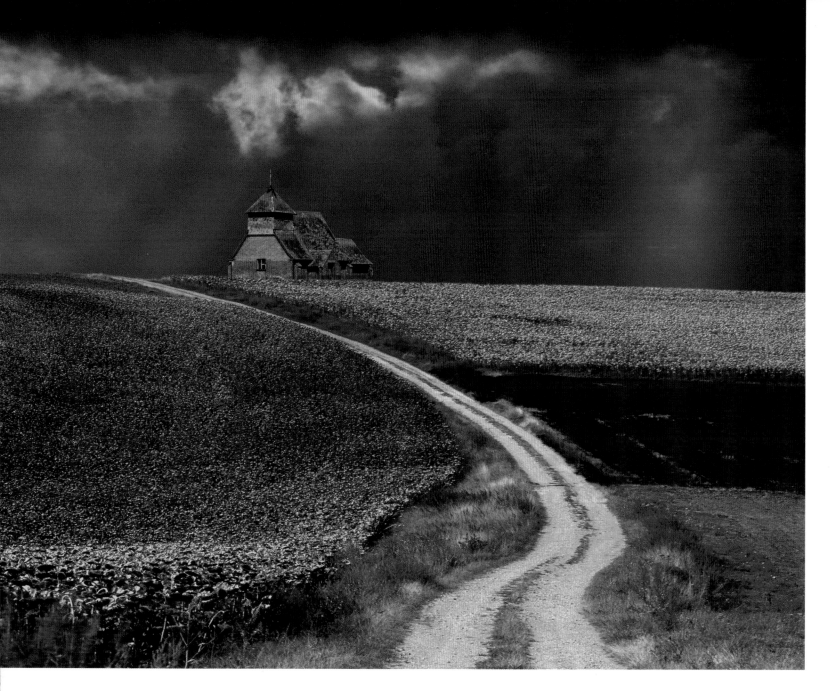

into a new layer placed between the sky and landscape, and then used Edit/Transform to alter its size and position so that its proportion looked about right in relation to the track, and the base of the church was just hidden behind the landscape. I reduced the opacity of this layer very slightly and applied a tiny amount of Gaussian Blur to make it look more in keeping with the background.

FINAL TOUCHES All that remained was to tweak the color, contrast and density of each layer until I achieved the most convincing balance.

Church, Romney Marshes, England
Creating a natural-looking montage of images is dependent upon them having a degree of compatibility in terms of lighting and perspective.

Finding Compatibility

The connection between the images combined in a montage does not necessarily have to be literal. In the image on the previous pages, for example, there is a compatibility between the individual elements, such as the shapes, colors and textures. Montage work can also be effective if there is only an implied logic that links the images.

rock nude

THE ELEMENTS The starting point for this image was a close-up photograph of the surface of a rock on a beach in North Devon, England. I was attracted by the cracked and veined quality of its surface, which suggested that by combining another image with it, I might be able to produce something of the quality of a cave painting. I first experimented with some images of animals, since they were often the subject of the early art works, but although interesting, the images lacked impact. It occurred to me that a nude could provide that essential eye-catching quality, and the contrast in texture between stone and flesh might give the image a further boost.

USING DARK TONES In searching through my files I found a photograph taken outdoors against a dark background, where the model had a quite strained and elongated pose that helped to make the image more abstract. Selecting a clean, cut-out torso was impossible, as the shaded area of her body blended with the dark background, but I thought that it might add to the ambiguous quality of the image if the body partially blended into the stone. Using Select/Color Range, I isolated the darkest tones of the nude photograph and then inverted it in order to copy the torso and paste it onto the rock image.

BOOSTING THE ROCK At this stage the rock looked too ordinary. I made a copy of it, applied the Find Edges filter to this layer and then inverted it, making a final adjustment to the effect by using Layer Options.

COMBINING THE ELEMENTS The most effective way to combine the nude torso with the

underlying rock image was by setting the Blend mode to Difference and making a slight adjustment in Layer Options.

A FINAL TOUCH I made a mask for the nude layer and painted out some unwanted detail, then tweaked the contrast, density and color saturation of each layer before flattening the image.

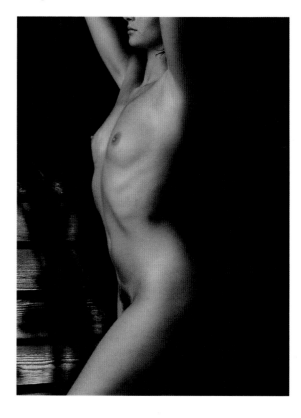

(ABOVE) **Nude**

MEDIUM-FORMAT CAMERA; LONG-FOCUS LENS; KODAK EKTACHROME 64

(OPPOSITE) **Rock face**

35MM CAMERA; LONG-FOCUS LENS WITH EXTENSION TUBE; FUJI VELVIA

(RIGHT) **Rock nude**
I think this image works partly because the shadowed area of the body has caused it to appear to merge into the stone.

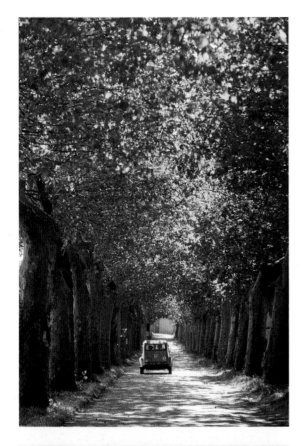

Archetypal Images

An image that identifies, at a glance, a place to which a travel brochure, book or magazine article refers, is one that is constantly in demand by publishers. In the case of France, this often means a shot of a lavender field, sunflowers or a turreted château. It occurred to me that it might be interesting to create a montage that had none of these as the subject, but at the same time said "France" very clearly.

france

THE BASIC ELEMENTS The first stage was to select a photograph with a relatively uncluttered background, but one that contained an element that established the image's location. This shot of a tree-lined avenue with a 2CV seemed to fit the bill. I wanted the image to have a human element, and the picture of a jovial French *vigneron* with his working blues and beret, glass in hand, pretty well chose itself. As he was fairly dark in tone and looking to the right, I placed him in the lower left corner of the frame.

ADDING MORE ELEMENTS The next image to be positioned was from a shot of a cottage doorway decked with flowers, and this seemed to want to be above the *vigneron*. I placed the red "Route des Vins" sign in the lower right corner to balance the red flowers and added the still life next to it quite small. I now felt that the biggish space at the top right should be filled with some ancient stone architecture, but I wanted to avoid using a château, as this could make the image too specific to a region. This shot of an old village house seemed just right.

CREATING BALANCE With all the elements in place, it was now a question of adjusting their size and position, using Edit/Transform to create a balanced composition. All the layers were set to Normal in Blend mode, but I adjusted the layer order and opacity of some of the layers to allow them to show through a little.

FINAL TOUCHES I made masks from all the layers, in order to paint out unwanted details and to make them merge as seamlessly as possible into each other.

(ABOVE LEFT) **Avenue**

35MM CAMERA; LONG-FOCUS ZOOM LENS; FUJI VELVIA

(LEFT) **Frenchman**

35MM CAMERA; MID-RANGE ZOOM LENS; KODAK EKTACHROME 100 SW

(TOP) **Blue shutters**

35MM CAMERA; MID-RANGE ZOOM LENS;
FUJI VELVIA

(ABOVE) **House**

35MM CAMERA; WIDE-ANGLE SHIFT LENS;
FUJI VELVIA

(RIGHT) **French montage**
*Using multiple layers makes positioning
and sizing the individual elements of
the image an easily adjustable process.*

Visualizing and Planning

Some of the best composite work is done by those with a strong sense of design who have the ability to visualize and plan their images. This is perhaps the most satisfying way of creating composite images, as the individual elements can be photographed especially for the purpose. In this way, objects can be made much easier to select by photographing them against a plain contrasting background, and it is possible to make sure that qualities such as lighting and perspective are common to all the images involved.

However, this is not my strong point. I tend to be inspired, and react more readily, to things I see and images that I already have. Many of my efforts in this genre are as a result of recognizing the potential of a particular photograph; I am then able to visualize the way in which other images could be combined with it so as to create a montage. Serendipity often plays a part, and some of my better composite images have happened as the result of a happy accident. This is one of them. The steps that I took to build the image were simply as a result of beginning to visualize the final outcome as I progressed, and making the necessary adjustments along the way to achieve this.

tattooed torsos

THE ELEMENTS I had been playing with ways of combining a nude with an image of flowers, and discovered an effect that looked rather like a tattoo. I decided to follow this up and began with a shot of a flower-filled meadow

Nude torso

MEDIUM-FORMAT CAMERA; LONG-FOCUS LENS; KODAK EKTACHROME 64; DIFFUSED STUDIO FLASH

Flowers

MEDIUM-FORMAT CAMERA; MID-RANGE ZOOM LENS; FUJI VELVIA

as the background layer. I copied and pasted onto this a shot of a nude torso that had been photographed against a black background.

CHANGING THE SHAPE I set the Blend mode to Difference and reduced the Opacity slightly, and gave the image a stranger appearance by using Edit/Transform to distort the shape of the torso. I then made a copy of this and placed it above, flipping it horizontally. I desaturated this image and set the blend mode to Luminosity.

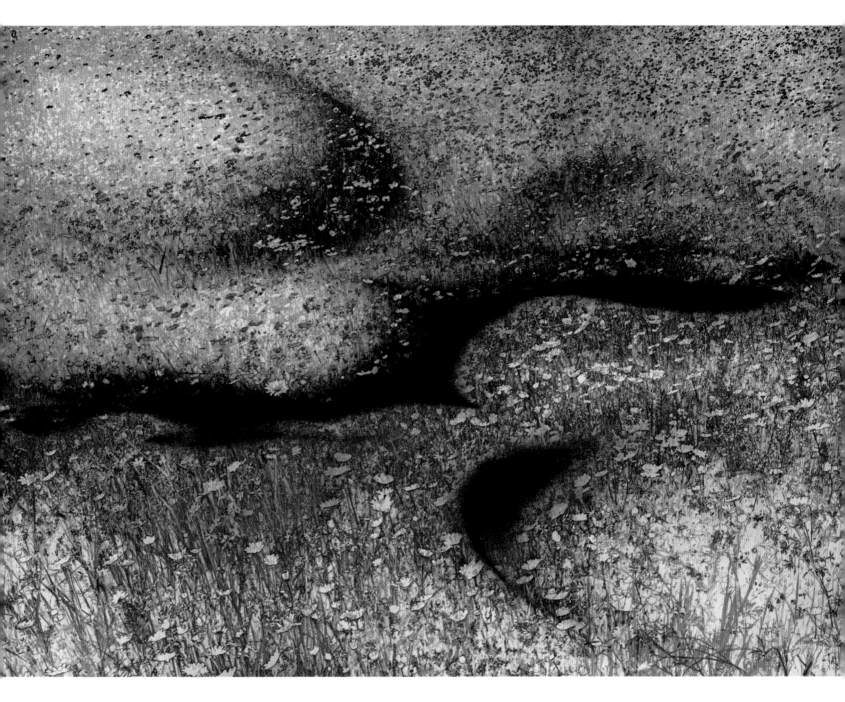

USING MORE LAYERS Having made a copy of the background layer, I placed this on top, with the Blend mode set to Difference. I made a further copy of the background layer, placed this on top and set the Blend mode to Darken. The penultimate step was to make masks for each of the layers in order to paint out unwanted details.

FINAL TOUCHES After the image had been flattened, I made a few final adjustments to the contrast, brightness and to the color saturation.

Tattooed torsos
Using multiple layers, different Blend modes and distortion using Edit/Transform, have all contributed to this image.

Making Composite Images Believable

One of the most difficult effects to achieve convincingly when creating composite images is to make the result seem like a straightforward photograph. Once you set out to deceive in this way, there are so many potential factors that can give the game away: discrepancies between lighting direction and quality, for example, or maybe inconsistencies in the perspective of objects, as well as the relative sharpness and the depth of field of different elements in an image. Achieving a believable result becomes more viable if the images you combine have a genuine unifying factor.

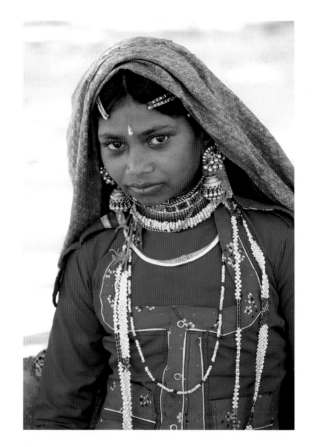

(ABOVE) **Indian woman**

35MM CAMERA; LONG-FOCUS ZOOM LENS; KODAK EKTACHROME 100 SW

(LEFT) **Wall and window**

35MM CAMERA; MID-RANGE ZOOM LENS; KODAK EKTACHROME 100 SW

woman and window

THE ELEMENTS I photographed this lady in Gujarat in India. It was the day of a tribal festival and she was waiting in the shade of a tree for the local bus, a bullock cart, to travel to the village where the event was taking place. The light under the shade of the tree was soft and ideal for a portrait, and with the use of a long-focus lens and a wide aperture I was able to throw the details behind her out of focus and create a fairly plain, uncluttered background. On the same day I also took some photographs in the village, including details of the streets and buildings. This shot of a blue wall was one that appealed to me because of its color, and I included the window simply as a compositional device. Looked at together, the two images seemed perfectly matched, as the open-shade lighting quality was identical and there was

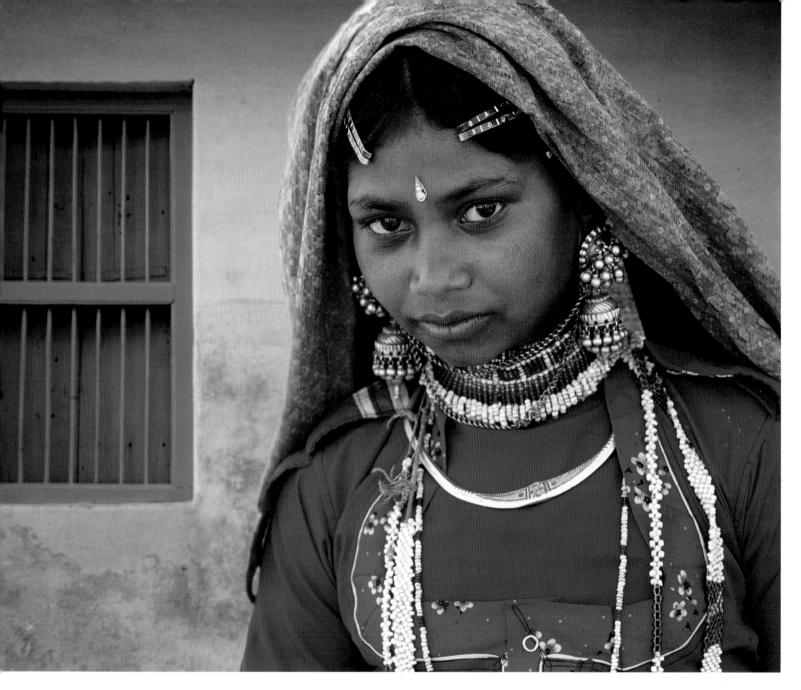

little in the perspective of the images to strike a wrong note.

COPYING AND PASTING Selecting the woman's background using the Magic Wand tool, I inverted and feathered it a little to copy it. I then pasted her onto a new layer above the wall and used Edit/Transform to adjust her size and position. This already looked quite convincing, but I applied a small amount of Gaussian Blur to the background to make sure it was slightly less sharp than the portrait.

HIDING THE JOINS I selected the woman's outline using the Lasso tool and applied a small amount of Gaussian Blur to this too, in order to make the join less apparent.

A FINAL TOUCH I used Image/Adjust-Replace Color to make the blue wall match the color of the dress more closely.

Woman and window
Similar lighting conditions, and an inherent compatibility between the two photographs, helped to make this picture a convincing montage.

Creating Composite Images • **139**

Working to a Brief

One way of beginning the process of creating a multiple image is to give yourself a brief. Imagine, for instance, that you are working with an art director who needs an image for a specific purpose: to illustrate a CD cover, perhaps, or a book jacket for a novel. It often needs something like this to stimulate the creative juices, and can lead you to developing ideas in ways you may not otherwise have considered. Diana, the art director for this book, told me that her company's sales department had suggested that the jacket image should have a "regular-guy" masculine appeal, and a sports car was suggested as a suitable image.

las vegas

THE ELEMENTS Some years ago, I photographed this rather outrageous sports car outside a Las Vegas hotel, and it did rather have the quality of a dream machine. At the same time I also photographed some street scenes of the city at dusk, and I felt that this particular one might be effective as a background image.

SELECTING THE CAR Because there was no clear distinction between the car and the surroundings, I used the Pen tool to create a path around its outline, enlarging the image considerably to isolate it as accurately as possible. I then converted the path into a selection, feathering it slightly, and then copied and pasted it onto a new layer above the street scene. I adjusted its size and position using Edit/Transform, and also rotated it slightly to create a steeper diagonal line across the frame.

USING A MASK I made a copy of the car layer and applied Motion Blur to it. I then made a mask for this layer in order to paint out the central details of the blurred image so the underlying, sharp car image showed through.

(LEFT) **Car**

35MM CAMERA;
WIDE-ANGLE LENS;
KODACHROME 64

(BELOW) **Diner**

MEDIUM-FORMAT
CAMERA; MID-RANGE
ZOOM LENS; FUJI VELVIA

(OPPOSITE BELOW)
Las Vegas street scene

35MM CAMERA; LONG-
FOCUS ZOOM LENS;
KODAK EKTACHROME 64

(ABOVE) **Las Vegas composite**
Using Blur and then adjusting the opacity of the different images helped them to blend satisfactorily.

ADDING A FINAL ELEMENT The composition was lacking at this stage and needed another element to help balance it. I had this shot of an old-fashioned American diner in New England, and copied just the top of this to paste onto the car and street scene, setting the Blend mode to Screen. I made a mask for this layer in order to paint out any unwanted details and to make the joins as seamless as possible.

Adding Interest

Sometimes a photograph taken because something about the scene or the subject appeals to me, but I'm not sure exactly what, simply does not have enough going on to make it entirely satisfying on its own. Prior to my interest in digital imaging, such photographs would have been consigned to the back of the filing cabinet under "pending," or would have been thrown out. This is one such image, but it was taken quite recently with the realization that I might be able to add that extra something to make it work.

ice-water nude

THE ELEMENTS The scene attracted me because of the astonishing color change in the water. This was a result of early morning sunlight being reflected from a cliff face onto the partially frozen stream, which contrasted dramatically with the blue cast created on the water by the shaded foreground. The logical connection here – which I like to have, as mentioned earlier – is a bit less tangible and can be explained only in tactile terms. To my mind, bare flesh and water have a perfectly logical connection, and it seemed obvious that a nude was needed for the secondary image. In the end, I used the image combined with the rock on page 132. Here, too, the fact that the outline of the body was not clearly visible all around was an advantage, as I wanted it to blend in with the water slightly.

DARKENING THE IMAGE I copied and pasted the nude onto a new layer above the water image, with the Blend mode set to Screen. The body

did not read clearly enough in certain places, so I used the Printing-in tool to darken the water image in these areas to give the highlights on the nude more emphasis.

FINAL TOUCHES At this stage the nude element of the image was a little too weak, so I made a copy of it, placing the new layer on top, and set the Blend mode to Multiply and the Opacity to 30 percent.

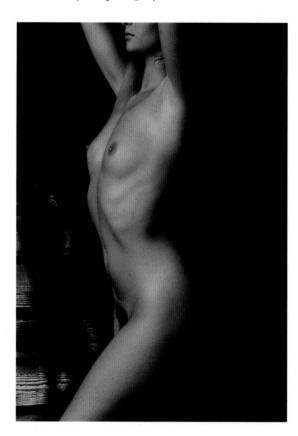

Nude

MEDIUM-FORMAT CAMERA; LONG-FOCUS ZOOM LENS; KODAK EKTACHROME 64

TECHNICAL NOTE

When making alterations to the background layer, such as shading or printing in areas of it, as here, I often make a duplicate layer and work on it. This allows me to see the effect being created very readily, and also makes it easy to revert to the original by dumping this layer if it goes wrong.

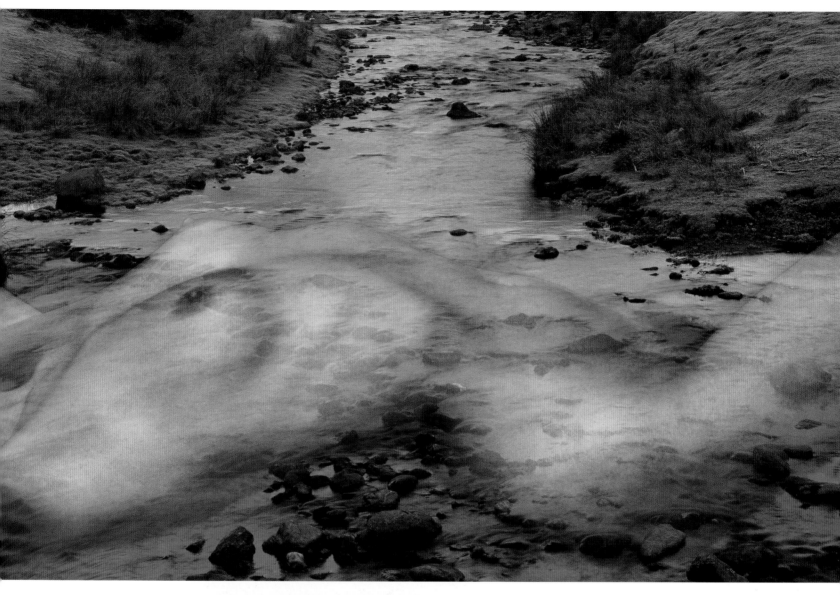

(RIGHT) **Ice water**

MEDIUM-FORMAT
CAMERA; LONG-FOCUS
ZOOM LENS; FUJI VELVIA

(ABOVE) **Ice water nude**
*I adjusted the opacity
of the top layer and the
density of the base to
create the right degree
of "see-through."*

Creating Composite Images ● **143**

Lettering

Although specialty programs such as QuarkXpress are available for laying out separate images on a page, it is quite easy to make composites in a similar way using an image-editing program like Photoshop. This can be used to create material with lettering for Web use or printing leaflets, posters, mailers, presentations and greeting cards, to give a few examples. I envisaged this composite as an Andy Warhol-style poster with a number of different versions of the same image.

Sunflower

35MM CAMERA;
LONG-FOCUS LENS WITH
AN EXTENSION TUBE;
FUJI VELVIA

sunflowers

CHOOSING THE IMAGE Because the sunflower was a simple shape against a plain background with bold colors, I thought it would read well when used quite small. It also had a range of tones and colors that would enable me to create some interesting variations. These were produced using a variety of the effects described in other chapters, such as Posterization, Find Edges filter, inversion, and distortions using Curves.

PLACING THE IMAGES My first step was to create a new file of the size I wanted the finished image to be. I then opened each of the sunflower files in turn and copied and pasted each onto the new file using Select All. Then with the aid of the grid and Edit/Transform I resized each image and positioned them, one at a time, in the way that is illustrated.

CREATING A BALANCE At this stage there was an imbalance between some of the images, so I went to each in turn and adjusted them using a mixture of Replace Color, Hue and Saturation, and Levels until I had a pleasing overall balance. I filled the base layer with a suitable color, adjusting this using Replace Color until I was finally happy with the complete effect.

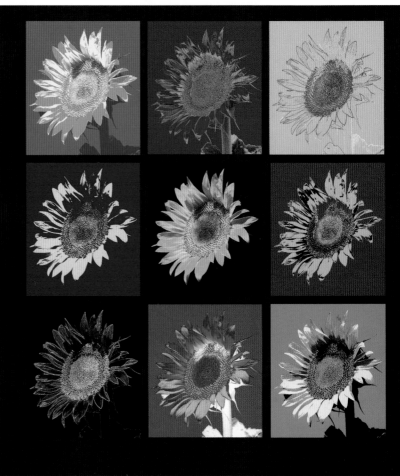

(ABOVE) **Sunflowers**
Using ten separate layers for this image allowed me to make final adjustments to each so I could obtain the best balance.

ADDING THE LETTERING

I opened a new layer and placed it on top and, using the Type tool, selected typeface, color and size before typing in the message. Using Edit/Transform I then adjusted the size and the position of the lettering, and used Layer/Effects to add a combination of Drop Shadow, Bevel and Emboss, and Inner Glow.

FINAL TOUCHES Setting the Blend mode to Overlay allowed the lettering to read quite well without obscuring the image too much.

(ABOVE) **Combined image with lettering**
Using a separate layer for lettering makes it easy to position and also allows the use of effects such as Drop Shadow and Emboss.

Creating Composite Images ● **145**

Digital Practicalities

For those new to the wonders of digital photography, an image-editing program such as Photoshop, can seem pretty complex and bewildering. And it certainly is if you try to take it all on board at once. I began by dealing with one stage of controlling an image at a time and learning the basic steps needed to achieve the result I wanted, with occasional ideas from magazine articles, tips from friends and by reading technical manuals.

It really doesn't matter if you don't know all the short-cut commands – the important thing is to be able to see in your mind's eye the image you want to achieve, and to understand what changes are required to bring it closer to this. The most important aspect of digital photography is not how adept you are at using a computer, or how knowledgeable you are about the technology, but how effective the end result is.

Pixelated landscape
I made the pixels an integral part of this image by creating a small file and printing at only 20 pixels per linear inch.

Capturing the Image

Using a digital camera
This is a section from a photograph taken on the Minolta Dimage 7, a 5.2 Megapixel camera at the maximum resolution of 2560 x 1920 pixels, giving a 300 PPI print of about 8.5 x 6.5in and interpolated up to 12in wide.

digital cameras

Things are progressing at an astonishing rate in the world of digital imaging, especially in the development of digital cameras. A couple of years ago many people would have said that a serious challenge to silver-based photography was a long way off for all but those with enormous budgets. But things are changing fast and the day when the quality of an image captured on a digital camera will match that of one captured on a film camera, at an affordable price, is not so far away. As I write this, it's just been announced that sales of digital cameras have outstripped those of film cameras for the first time. A sign of the times.

The number of pixels a camera is capable of recording is the basic consideration when calculating the degree by which an image can be enlarged to give a result comparable to a film image. In practice this can be increased by interpolation but the resulting quality will depend partly on the nature of the image and the degree of enlargement. But the number of pixels is not the only factor determining image quality because the lens, the software and the way in which the images are stored will all have a significant effect on the quality of the final image.

One difference to consider between a digital camera and one using film is that, with the latter, for a given format and beyond a certain price level, different models will give very similar results when used to their full potential, and differences in image quality will be distinguished mainly by the nature of the subject and the choice of film. But with digital-image capture the camera itself largely determines the quality of the recorded image, and this can vary considerably from model to model as well as according to cost.

It's also important to appreciate that the image capture area of the current generation of 35mm digital cameras is significantly less than 24 x 36mm. This means that the image must be enlarged more to create the same sized print and that the lenses are of a shorter focal length than their true 35mm equivalent and the depth of field will be greater.

Image storage is another issue to be considered. A 16Megabyte memory card would hold only one image of the file size shown on this page and a good day's photography would require carrying many such cards, or a portable hard drive on which to periodically download the photographs. The time taken to save a high-resolution image must also be considered – it's by no means as instant as film, and digital cameras use battery power so fast it makes your eyes water.

film cameras

It's fair to say that a good-quality film camera combined with a slow, fine-grained film is capable of producing high-quality images of about 20 x 16in. This would require a huge amount of storage space in digital storage terms and when you consider that a roll of 35mm film can store 36 such images, costs little, does not need batteries and is very small, it places film in a true perspective. Admittedly, it can only be used once and you have to wait for the film to be processed and must take the time to scan it

– but it's still a remarkably efficient, compact and cost-effective way of storing an image.

This is the main reason why I have used film to record most of the images used in this book. From my point of view, by far the greatest amount of time and effort I devote to taking a photograph goes into being in the right place at the right time – sometimes this can represent several days at appreciable cost – and I think it would be foolish then to record the image in a way that would restrict the size at which it could be used forever by recording it on a digital camera.

Of course this is changing, and I now believe the time is not too far away when we will be able to record images digitally at the same resolution, and at a similar cost, to that of a film camera; but this time has not come quite yet. I really do like the idea of being able to judge within moments of taking a shot just how successful, or otherwise, it has been and whether, while I still have the chance, I could improve it by changing the viewpoint or the way it is framed, for example, or indeed simply to trash it on the spot. One major problem with shooting transparencies, as I have done for very many years, is the chore of editing and the inevitable accumulation of doubles and similars; consequently the ability to be much more selective at the time of shooting really does appeal to me.

scanners

Images that have not been recorded on a digital camera have to be scanned in order to convert them into pixels. There are three basic types of scanner, and they are available in a very wide range of prices and resolution capability. It is the number of pixels per inch a scanner can create optically, without interpolation, that determines the resolution and potential image quality it will produce. But as with cameras, pixels alone do not determine the ultimate quality: D Max and Bit Depth are also important factors. D Max is the scanner's ability to record the density range of a transparency, and the Bit Depth defines the amount of color information it can record. The higher these ratings are, the better the scan will be – a factor of 3 should be considered a minimum requirement for the D Max, and 24 for the Bit Depth.

At the very highest level, costing as much as a house, are the drum scanners used by repro houses and bureaus. These produce the highest levels of resolution and image quality, and can scan both transparencies and reflective flat copy or artwork. But they are by no means user-friendly, as transparencies have to be coated in oil to be placed into contact with the drum, and cleaned afterward.

Flatbed scanners are designed primarily for use with reflective material such as artwork, photographic prints and pages of text. They can be relatively inexpensive and most can be adapted to scan transparencies, but they do not produce the same resolution or image quality from this medium as a drum scanner or a dedicated film scanner.

Desktop film scanners are the best option for those who wish to make reasonably large-sized prints from their negatives or transparencies from 35mm transparencies or negatives, and are relatively inexpensive compared to a digital camera with a similar resolution. Film scanners that also handle medium-format and 5 x 4in materials are rather more expensive. But the quality of all these devices is constantly rising while the cost is reducing, and the gap between the quality of a drum scanner and that of a good desktop film scanner is constantly narrowing.

the computer

A computer used for manipulating digital images for output at photo or repro quality needs to have a reasonably large amount of RAM. An RGB image to be used at around 8x10in will create an uncompressed file size of about 30MB (megabytes), and the amount of RAM needed to handle a file this size can be several times this, especially when layers are used. For this reason, 128MB of RAM should be considered a practical minimum, although if your images are only needed for use on the Web, a smaller amount of memory can be adequate. It is also wise to buy the best monitor you can afford, as a large, high-resolution screen makes working with images easier and more enjoyable.

file storage

Once you begin to create images in the computer, it's amazing how rapidly your hard disk begins to fill up, and you will soon find it necessary to use a means of exterior storage. The best option, and the one most commonly used by photographers, is a CD writer, which can store up to 650MB on a disc and is quite inexpensive; this represents over 20 8x10in-plus-size images at 300PPI (pixels per

inch) without compression. A rewritable CD recorder is an alternative option, although the discs are more costly, and there are also devices such as Zip and Jaz drives, where the portable disc can be reused.

Scanned images

I used an inexpensive flatbed scanner to capture these two images, which were placed on the glass and scanned as reflective media as if they were documents. They were then adjusted and combined in Photoshop.

Resolution and Color

resolution

When I first starting working with digital images, I found the concept of resolution one of the most difficult things to grasp – but it's not really that complicated. Part of the problem is that the term DPI (dots per inch) is used to describe the resolving capacity of an inkjet printer in terms of ink droplets, as well as sometimes that of a digital image, where it is really referring to pixels per inch. But they are quite different, and if you think only of pixels when dealing with a digital image on the computer, the matter of resolution seems much easier to grasp.

A digital image needs around 300PPI (pixels per linear inch) in order to produce high-quality photographic reproduction, either by litho printing or other means, such as inkjet printing, on good-quality paper. It can be seen therefore that a 1in-square image needs about 90,000 pixels to fill the space, or, looking at it another way, 1,000,000 pixels produce a good-quality, 300PPI image of 11sq in, or just under 3 x 4in.

file size

The greater number of pixels there are in an image, the larger the size of the file will be. A color image of 1,000,000 pixels, rendered in RGB, occupies an uncompressed file of just over 3MB. In black and white or Grayscale, this file would be reduced by two-thirds, and in CMYK, used in litho printing, it would be increased by one third.

file storage

There are a number of ways in which image files can be stored or saved. The widely used TIFF format preserves all of the information when used uncompressed, but uses up a lot of storage space. A file format like JPEG is quite economical and offers various levels of compression, enabling the file size to be reduced dramatically, but at the cost of losing some of the information each time it is opened and closed.

color

It helps a great deal to understand how color is defined in photographic terms. The primary, or additive, light colors are red, green and blue. If a red light is projected onto a white screen in a darkened room it appears red. If a green light is added to this, the result is yellow, and when a blue light is added, the screen appears white. When just the blue and green lights are projected, the screen is Cyan in color, and with red and blue light it is called Magenta.

The colors Cyan, Magenta and Yellow are known as the secondary, or subtractive colors, and are those used by the litho-printing process and inkjet printers. When a 100 percent Yellow pigment or ink is added to pure Cyan, a primary green is created, and when 100 percent Magenta is added to this combination, the result is black. Cyan and Magenta produce blue, while Magenta and Yellow create red. By varying the percentage of each primary or secondary color, all the visible colors can be created, on film or by projection in the case of the former, and by pigment, dye or ink on paper for the latter.

A

B

C

D

Comparative pixel numbers
This image of an Indian tower is reproduced at:

A *25 pixels per linear inch*
B *75 pixels per linear inch*
C *150 pixels per linear inch*
D *300 pixels per linear inch*

Controlling Image Quality

Color and density variations

The central image shows the photograph adjusted for density and color balance, while the effect of making the image lighter is seen on the left, and darker on the right. The three images above, from left to right, show a red, green and blue color cast, while the three images that are shown below illustrate the effect of a Cyan, Magenta and Yellow color bias respectively.

Even the most experienced photographers have difficulty on occasions in judging the quality of an image and deciding what is needed to improve it. The traditional method used in the darkroom, making test strips, is perhaps the best and easiest way of assessing things like density, color and contrast, and can be applied readily to digital control.

It can help a great deal to save the first stage of an image and, as soon as you begin to make changes, save it again with a different name. In this way you can always make side-by-side comparisons with the original as you progress. It is also worth making test strips that can be printed out to help you judge image quality more accurately. An image on a screen tends to be difficult to assess until you have gained some experience: one way is to use the Marquee tool to select a series of strips across an image and alter each one in a predetermined and carefully recorded way.

To begin with, use the basic controls of Brightness, Contrast and Color Balance to begin with, making use of the Variations options in the Image/Adjust menu, and then progress to Levels and Curves as you become more proficient. When you want an image to have either areas of pure white or black, it is best to establish these at the outset, using the eyedropper to sample the details you wish to render in this way.

making a selection

Selecting a precise part of an image is a frequently needed basic digital technique, and there are a variety of ways of doing it. When there is a clear tonal or color distinction between the part of the image you wish to select and its background, the Magic Wand tool can be very effective, as it can be adjusted to make a progressively finer selection as you enlarge the image and close in on details you wish to isolate.

With many images, for example those where an object or detail is clearly contrasted against a background, the Color Range method of selection can be quick and easy to use, and has the advantage that the selection can be widened or narrowed by using the Fuzziness slider or by taking additional samples from the image. It is also possible to aid this method of selection by making a duplicate layer of the image in question and increasing the contrast, density or color saturation to enhance the difference between the areas you wish to select and the others.

Where there is little clear distinction between the outline of the detail you want to select and its background, the Lasso tool can be effective, especially if you enlarge the image to 100 percent or more on the screen. You can have even more control by using the Pen tool to create a path around an object's outline and then converting this into a selection.

Using the Channels menu to select either the red, green or blue content of the image

can also often reveal a stronger differential – the most effective channel can be copied and the contrast and brightness adjusted to maximize the difference. Whichever method of selection or combination you choose, using Quick Mask enables you to tidy it up and see more readily how accurate your selection has been. For someone who needs to make accurate selections of objects from backgrounds frequently, there are a number of specialist programs designed for this purpose, such as Extensis Mask Pro.

A degree of feathering is often desirable, since the hard edge of a selection can often intrude. The amount of feathering you need to apply is dependent both upon the nature of the subject and the effect you want, and also on the size of the file. A feather of five pixels is quite subtle on a 50MB image, but quite noticeable on one of 5MB.

image sharpness

Most images made up of pixels can benefit from being sharpened, and the best way to do this is to use Unsharp Masking. This is based on a traditional darkroom technique of improving the apparent sharpness of an image by sandwiching a weak, unsharp copy of an image in contact with the original negative. This enhances the contrast between the edges of tones and colors and is similar to the effect of using a high-acutance developer in black-and-white photography.

There are three controls, Amount, Radius and Threshold, and it is really a matter of trial and error to find the best setting for a given image. The best setting also depends upon the size of the file and the nature of the subject. A suitable starting point for an image of about 30MB would be Amount 200 – 300 percent, Radius 1.0 – 2.0 pixels, and a Threshold setting of level 1– 5.

Bear in mind that with an image of 300PPI the image on the screen will be about four times larger than it appears when printed. This is because the monitor only displays about 70PPI. In this situation I would view the effect of using Unsharp Masking with the image displayed at 50 percent, and to get an accurate impression the image is best viewed at the set ratios of either 25 percent, 50 percent or 100 percent. Film grain and dust become much more prominent when Unsharp Masking is applied, as do any artefacts created by pixel manipulation.

Using Unsharp Masking
The right side of this image is shown as it was scanned, while the left image shows the effect of applying Unsharp Masking. The file size was 23MB and the Unsharp Masking was set at: Amount 250 percent, Radius 1.5 pixels, and Threshold level 5.

Outputting the Image

When you have created an image on your screen with which you are happy, and have saved it onto your hard disk, there are a variety of things you can do with it. You can send it by email to a friend, for instance, store it on a disk and send it to a photo lab to be printed on photographic paper or film, make a print from the file on your own inkjet printer, or place it on a website.

In a perfect world, the image would appear the same wherever the file was opened, but sadly it's not quite as simple as that. I have two computers and the monitors have both been calibrated to the manufacturers' instructions, but the same file when opened on one looks slightly different from how it does on the other.

It is quite possible that the image you send by email will look a little different to each and every person who receives it. Moreover, the various ways in which the image is used also affect its appearance. The image your inkjet printer produces can be different from that displayed on your monitor, and is different again from the way it will reproduce on the pages of a book or magazine.

One reason for this is that the color make-up is different. An image reproduced on a color transparency or computer monitor is seen by transmitted light, which is made up of red, green and blue layers, whereas an image recorded on an inkjet printer or by litho reproduction is viewed by reflected light, and the inks that lay down the color on the paper are made up of Cyan, Magenta and Yellow. In the case of litho printing, Black is also used, because even when the colored inks are mixed at 100 percent density, they do not produce a really dense, juicy black. In the case of inkjet printers, the color cartridge also contains lighter hues to compensate for the shortcomings of the pigments used.

Although special software for color management is available, for all but the most exacting worker and those working directly with repro houses and bureaus, the most practical method is to ensure that your monitor matches as closely as possible the methods of outputting that you use regularly. Your monitor first needs to be adjusted according to the manufacturer's instructions, or for the program you are using. With Photoshop the process is carried out with Adobe Gamma, and the steps are clearly described.

If you wish to calibrate your monitor to the output of, say, an inkjet printer, make a print with no adjustments from a file that looks correct on your monitor, and compare the two. The first attempt is unlikely to produce a good match, so alter the image on the monitor to match the print. The best way to do this is to use a Gamma Control program, such as that made by Knoll software. This allows you to alter the density, contrast and color quality of the image on the screen to match a particular output, and the settings can be saved in that name. I have, for instance, different settings for use with my film recorder, printing on watercolor, photo-quality gloss and double-sided matt paper for presentations, as well as for supplying image files to a printer for reproduction. It is necessary to allow your monitor to warm up thoroughly before doing this, with the room darkened and the image you wish to match illuminated by the source by which it will be viewed, such as a daylight tube.

A

B

C

D

Litho-printing colors

This shows how each of the four colors in the litho-printing process, Cyan, Magenta, Yellow and Black can, by their differing proportions within the image, recreate virtually all the colors in the visible spectrum with remarkable accuracy. The top left image shows all four colors, the next Cyan only, then Cyan plus Magenta, and the third shows Cyan, Magenta and Yellow.

A *The full four-color image photographed on a 35mm camera with a mid-range zoom lens using Fuji Velvia.*
B *The Cyan layer only was printed for this image.*
C *This shows the effect of combining the Cyan and Magenta layers.*
D *Here just the Cyan, Magenta and Yellow layers have been combined without the Black.*

Acknowledgments

First, I would like to thank Doreen Montgomery, who set the wheels turning by introducing me to Anna Watson, to whom I'm grateful for having commissioned me to produce a book that I had been thinking about for some time. My thanks also go to Sarah Hogget, who carried on with the project when Anna left to pursue other interests. Diana Dummett has succeeded in weaving together some pretty disparate elements into an effective and cohesive design for which I'm very grateful, as I am to Freya Dangerfield for the thorough and meticulous way she kept her eye on the ball as it bounced around between conception and reality. I'd also like express appreciation to Ian Kearey for his careful and sympathetic polishing of my prose, and to Carole Trillian of Minolta for her help in arranging for me to use the newly launched Dimage 7 camera. I also owe thanks to my friend Jim Panks, a true Mac wizard, who helped both me and my computer rise to the frequent new demands being made upon us.

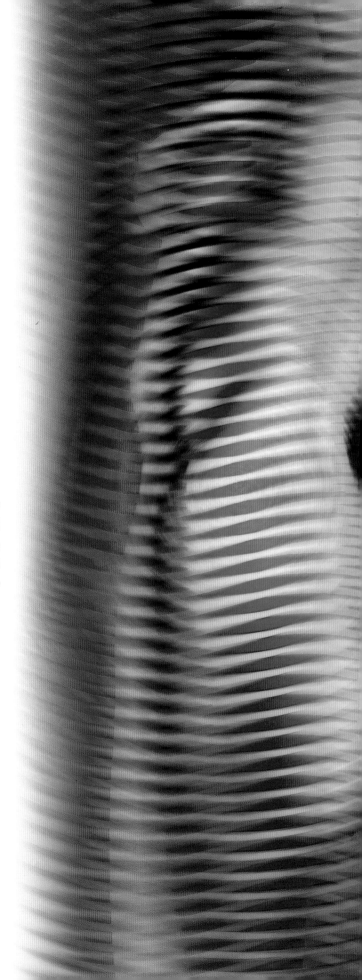

Index

Illustrations are shown in *italic*